COCKTAIL INTERNATIONAL

ROBERT LUCANDER

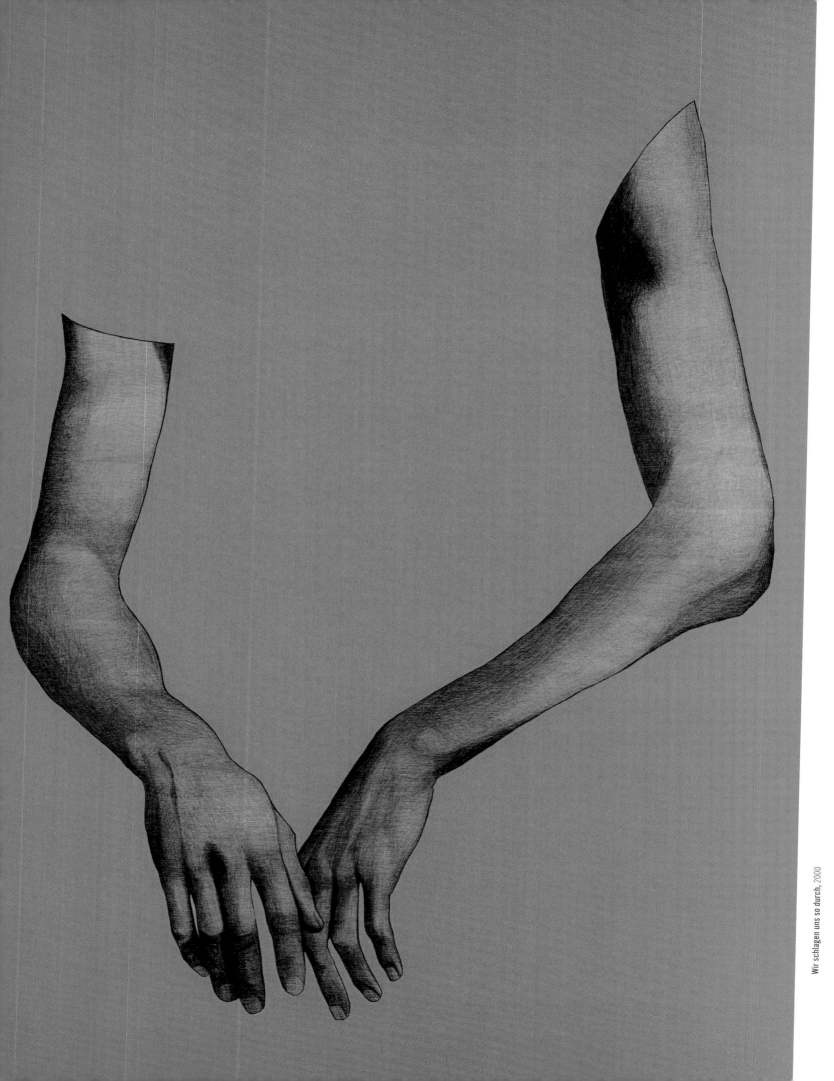

COCKTAIL INTERNATIONAL

Herausgegeben von
Edited by
Oliver Zybok

Mit Textbeiträgen von
With contributions by
Beate Ermacora
Harald Falckenberg
Oliver Zybok

HATJE
CANTZ

ROBERT LUCANDER

Diese Publikation erscheint anlässlich der Ausstellung
This catalogue is published in conjunction with the exhibition

Robert Lucander. Cocktail International – ALLES ORIGINAL REMIX
Kunstmuseum Mülheim an der Ruhr in der Alten Post
14.05.–23.07.2006
Robert Lucander. Cocktail International – Instrumental
Museum Baden, Solingen
10.09.–29.10.2006

KATALOG CATALOGUE

Herausgeber Editor
Oliver Zybok

Katalogkonzeption Catalogue concept
Robert Lucander, Oliver Zybok

Redaktion Editing
Oliver Zybok

Grafische Gestaltung und Satz Graphic design and typesetting
Melanie Berens, Käte Schiegler

Lektorat Copyediting
Antje Utermann, Deutsch I German
Bronwen Saunders, Englisch I English

Übersetzungen ins Englische Translations into English
Allison Plath-Moseley

Schrift Typeface
Trade Gothic Condensed, Gesso

Papier Paper
UPM Finesse premium silk, 170 g/m²

Buchbinderei Binding
Bramscher Buchbinder Betriebe GmbH & Co. KG, Bramsche

Reproduktionen und Gesamtherstellung Reproductions and printing
Dr. Cantz'sche Druckerei, Ostfildern

© 2006 Hatje Cantz Verlag, Ostfildern, und Autoren I and authors
© 2006 für die abgebildeten Werke von Robert Lucander beim Künstler I
for the reproduced works by Robert Lucander: the artist;
für die abgebildeten Werke von I for the reproduced works by Francis
Bacon, Blinky Palermo und I and Francis Picabia: VG Bild-Kunst, Bonn;
sowie bei den Künstlern oder ihren Rechtsnachfolgern I the artists, and
their legal successors

Erschienen im Published by
Hatje Cantz Verlag
Zeppelinstraße 32
73760 Ostfildern
Deutschland I Germany
Tel. +49 (0)711 4405-0
Fax +49 (0)711 4405-220
www.hatjecantz.com

Hatje Cantz books are available internationally at selected bookstores
and from the following distribution partners:
USA/North America – D.A.P., Distributed Art Publishers, New York,
www.artbook.com
UK – Art Books International, London, www.art-bks.com
Australia – Tower Books, Frenchs Forest (Sydney),
towerbks@zipworld.com.au
France – Interart, Paris, commercial@interart.fr
Belgium – Exhibitions International, Leuven, www.exhibitionsinterna-
tional.be
Switzerland – Scheidegger, Affoltern am Albis, scheidegger@ava.ch
For Asia, Japan, South America, and Africa, as well as for general ques-
tions, please contact Hatje Cantz directly at sales@hatjecantz.de, or
visit our homepage www.hatjecantz.com for further information.

ISBN-10: 3-7757-1756-0, ISBN-13: 978-3-7757-1756-4
Printed in Germany

Umschlagabbildung Cover illustration
Robert Lucander, *To Sex Something Up*, 2004, Acryl und Bleistift auf
Holz I acrylic and pencil on wood, 100 x 70 cm, Privatbesitz I privately
owned

Fotonachweis Photo credits
Gunter Lepkowski, Jochen Littkemann,
Robert Lucander, Berlin,
Christian Westerback, Helsinki

AUSSTELLUNG EXHIBITION

Gesamtkoordination General coordination
Oliver Zybok

Museum Baden, Solingen
Wuppertaler Straße 160
42653 Solingen
Tel. +49 (0)212 25814-0
Fax +49 (0)212 25814-44
museum-baden@t-online.de
www.museum-baden.de

Direktor Director
Rolf Jessewitsch

Ausstellungskonzeption Exhibition concept
Robert Lucander, Oliver Zybok

Koordination Coordination
Gisela Elbracht-Iglhaut

Sekretariat Office
Susanne Vieten

Öffentlichkeitsarbeit Public relations
Gisela Elbrecht-Iglhaut

Ausstellungstechnik Technical support
Bernhard Bauch, Dieter Hartnick, Manfred Sehn

Kunstmuseum Mülheim an der Ruhr in der Alten Post
Viktoriaplatz 1
45468 Mülheim an der Ruhr
Tel. +49 (0)208 4554171
Fax +49 (0)208 4554134
kunstmuseum@stadt-mh.de
www.kunstmuseum-mh.de

Direktorin Director
Beate Ermacora

Ausstellungskonzeption Exhibition concept
Beate Ermacora, Robert Lucander

Koordination Coordination
Ines Wiskemann

Sekretariat Office
Elke Morain, Sandra Vella

Verwaltung Administration
Lothar Kronenberg

Ausstellungstechnik Technical support
Klaus Hajek, Heiner Riemer

Kunstvermittlung Art education
Gerhard Ribbrock

Mit freundlicher Unterstützung von Kindly supported by

Art Sponsoring Solingen

Eugen-Otto-Butz-Kunst-Stiftung

Taiteen Keskustoimikunta

versichert über
Artscope

UPM

BILDNACHWEIS LIST OF WORKS MENTIONED

Seite I page 9
Kasimir Malewitsch, *Suprematistisches Gemälde: Acht Rote Rechtecke*,
1915, Öl auf Leinwand I oil on canvas, 57,5 x 48,5 cm, Stedelijk Mu-
seum Amsterdam

Seite I page 10
Blinky Palermo, *Straight*, 1965, Öl und Bleistift auf Leinwand I oil and
pencil on canvas, 80 x 95 cm, Bayerische Staatsgemäldesammlungen,
Pinakothek der Moderne, München

Seite I page 11
Siehe Kat. S. I see cat. p. 100

Seite I page 12
Francis Picabia im I at the Chateau de Mai, Mougins, um I circa 1934,
Foto I photo: Olga Mohler, *Album Francis Picabia*, S. 64 I p. 64

Francis Picabia, *Autoportrait*, um I circa 1940, Öl auf Karton I oil on
cardboard, 83 x 72 cm, Privatsammlung I private collection

Seite I page 13
Petrus Camper, *Über den natürlichen Unterschied der Gesichtszüge in
Menschen verschiedener Gegenden und verschiedenen Alters. Über das
Schöne antiker Bildsäulen und geschnittener Steine, nebst einer Dar-
stellung einer neuen Art, allerlei Menschenköpfe mit Sicherheit zu
zeichnen*, Berlin, Voss 1792, 4°, XX, 97 (77) SS., X Bl., 10 Taf., Privat-
sammlung I private collection

Werbeplakat für ein Kosmetikprodukt I Poster advertising a cosmetic
product, Berlin-Mitte 2003, Foto I photo: Robert Lucander

Seite I page 14
Unbeklebte Plakatwand I Empty billboard, Berlin-Mitte 1991, Foto I
photo: Robert Lucander

Seite I page 15
Francis Bacon, *Study for a Pope IV*, 1961, Öl auf Leinwand I oil on can-
vas, 152 x 119 cm, Privatsammlung I private collection

Siehe Kat. S. I see cat. p. 101

Dank an Thanks to
Lena, Lovis, Nicole Hackert, Bruno Brunnet, Philipp Haverkampf, Ilona
Anhava, Hans-Georg Lobeck, Sven Drühl, Jochen Littkemann, Robert
Lassenius, Hasir Ocakbasi, Paris-Bar, Contemporary Fine Arts, Berlin,
Galerie Anhava, Helsinki, UPM-Kymmene, Taiteen Keskustoimikunta

INHALT CONTENTS

VORWORT. **COCKTAIL INTERNATIONAL**

Robert Lucander serviert seinen *Cocktail International* an zwei Ausstellungsorten: im Museum Baden in Solingen und im Kunstmuseum Mülheim an der Ruhr. Es ist die erste Museumsausstellung in Deutschland, die einen Überblick über das Gesamtwerk des finnischen Malers gibt. Im Œuvre von Robert Lucander spielt von Anfang an die Frage nach dem Stellenwert von Original und Kopie eine entscheidende Rolle. Seine frühen Abstraktionen sind nicht als individuelle Entwürfe zu verstehen, sondern als eine Reflexion auf den Begriff der modernen Malerei. Er zitiert, stets mit gezielt gesetzten Irritationsmomenten, wegweisende Positionen der gegenstandslosen Malerei unter Verwendung von ungemischten Lackfarben. Erscheint zunächst der folgende Schritt seiner künstlerischen Entwicklung wie ein Bruch, so eröffnet seine Hinwendung zur Figuration jedoch ein neues Spielfeld, das es ihm erlaubt, sowohl die Geschichte der Malerei als auch die der Medien miteinzubeziehen.

Der Ausstellungstitel *Cocktail International* verweist in mehrere Richtungen. Zum einen auf Robert Lucander selbst, der als schwedischer Finne in Berlin lebt, zum anderen auf die Tatsache, dass sich die zeitgenössische Kunst und damit auch seine eigene aus vielen, nicht mehr zu verortenden Quellen speist und dass Political Correctness stets eine Frage des Standortes ist. Direkt bezieht sich der Titel jedoch auf eine Folge von drei Schallplatten mit demselben Motto aus den 1960er/70er Jahren. Hinter der Coverfassade aus gespiegelten Gin-, Martini- oder Whiskeyflaschen mit Gläsern verbergen sich Schlagerpotpourris, die teils vokal, teils instrumental ineinander übergehen und als Animation für diejenigen gedacht waren, die zu Hause einmal Bar spielen wollten. Lucander, Sammler von Vinylplatten, greift für die Ausstellung, die er in *Cocktail International – Instrumental* und *Cocktail International – ALLES ORIGINAL REMIX* zwischen Solingen und Mülheim aufteilt, auf Gepflogenheiten der Musikbranche zurück – ein Stück ist die Variation und das Surrogat des anderen und keiner weiß mehr so genau, wie das Original eigentlich klingt.

Wir danken zuallererst Robert Lucander herzlich für sein persönliches Engagement bei der Konzeption der Ausstellung, die er in vielen Gesprächen mit uns vorbereitet hat. Ebenso gilt unser Dank Oliver Zybok als alleinigem Koordinator, als Herausgeber des Katalogs und als kenntnisreichem Autor. Wir freuen uns, dass Harald Falckenberg, der sich schon früh für Werke von Robert Lucander begeistern konnte, mit seiner Sichtweise den Katalog bereichert hat. Für die großzügige Unterstützung des Projekts danken wir ferner Hans-Georg Lobeck, der Galerie Contemporary Fine Arts, Berlin, und der Galerie Anhava, Helsinki, sowie allen Leihgebern. Für die ideenreiche Kataloggestaltung gilt unser Dank Melanie Berens und Käte Schiegler. Die Ausstellung wäre ohne

PREFACE. **COCKTAIL INTERNATIONAL**

Robert Lucander is serving up his *Cocktail International* in two places: at the Museum Baden in Solingen and at the Kunstmuseum Mülheim an der Ruhr. This is the first museum exhibition in Germany to provide an overview of the Finnish painter's oeuvre—an oeuvre in which the status of original and copy has always had a crucial role to play. Lucander's early abstract works should not be regarded as individual compositions, but rather as a reflection on how modern painting is understood. In these works, he uses unmixed enamel paints to cite some of the pioneers of abstract painting, but always with carefully placed disturbances. As much as the next stage in his artistic development may seem an abrupt change, his switch to figuration has actually opened up a new playing field that allows him to include both the history of painting as well as that of other media.

The title *Cocktail International* refers to several things: for one, to Lucander himself, a Swedish-Finnish painter living in Berlin, for another, to the fact that contemporary art (and therefore his own) is fed by many—now obscure—sources and to the fact that political correctness is always a question of standpoint. Directly, however, the title refers to a series of three records from the sixties and seventies that bore the same motto. The cover façades of reflected gin, martini, or whiskey bottles and glasses conceal single-track potpourris of pop music—some of it vocal, some instrumental—originally intended as background music for people wanting to play bartender at home. As a collector of vinyl albums, Lucander not surprisingly resorts to typical music industry practices in his exhibition. This means that any given piece in *Cocktail International—Instrumental* in Solingen and *Cocktail International—ALLES ORIGINAL REMIX* in Mülheim is both a variation of and surrogate for another so that in the end, nobody really knows what the original sounds like.

We would first like to thank Robert Lucander himself for his personal commitment to the conception of this exhibition, which was prepared in the course of numerous conversations with us. Our thanks also go to Oliver Zybok as sole coordinator, editor of the catalogue, and knowledgeable author. That Harald Falckenberg, who has long been interested in Lucander's work, agreed to enrich the catalogue with his own personal perspective was also very gratifying. Thanks are also due to Hans-Georg Lobeck, the Galerie Contemporary Fine Arts, Berlin and the Galerie Anhava, Helsinki, for their generous support of the project and to all those who kindly lent us works. We would also like to thank Melanie Berens and Käte Schiegler for their imaginative catalogue design.

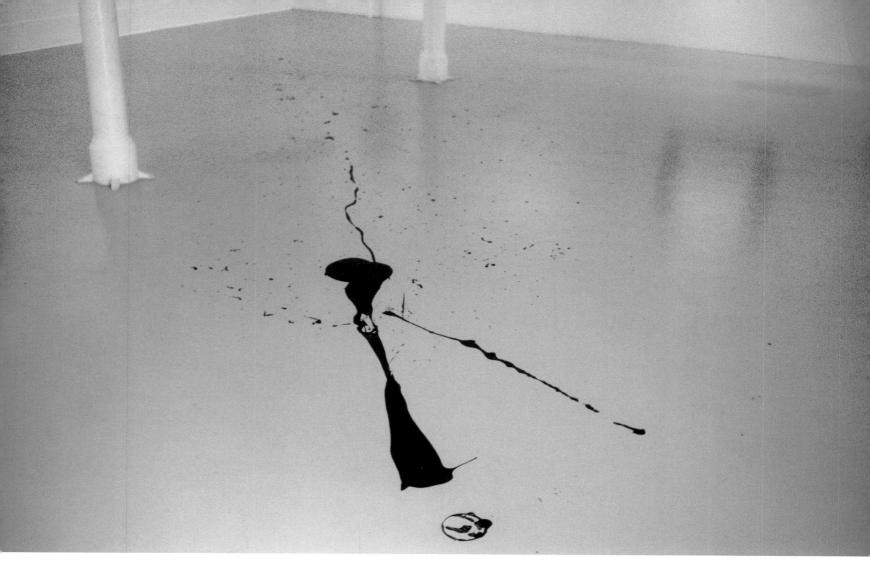

die großzügige Unterstützung von Unternehmen und Stiftungen nicht möglich gewesen. Das Museum Baden dankt dem Art Sponsoring Solingen und der Eugen-Otto-Butz-Kunst-Stiftung für die finanzielle Unterstützung, das Kunstmuseum Mülheim den Unternehmen UPM-Kymmene und Taiteen Keskustoimikunta. Den organisatorischen und technischen Museumsteams möchten wir abschließend an dieser Stelle ebenfalls unseren herzlichen Dank aussprechen.

Beate Ermacora
Direktorin Kunstmuseum Mülheim an der Ruhr in der Alten Post

Rolf Jessewitsch
Direktor Museum Baden, Solingen

The exhibition would not have been possible at all without the generous support of various companies and foundations. The Museum Baden would therefore like to thank Art Sponsoring Solingen and the Eugen-Otto-Butz-Kunst-Stiftung for their financial support, and the Kunstmuseum Mülheim the companies UPM-Kymmene and Taiteen Keskustoimikunta. We are also indebted to the organizational and technical teams of both museums for all the hard work they have put into this project.

Beate Ermacora
Director, Kunstmuseum Mülheim an der Ruhr in der Alten Post

Rolf Jessewitsch
Director, Museum Baden, Solingen

Probably the Best Red Painting in the World, Ausstellungsansicht I as exhibited
Originalstora arbeten i DIN-format, Forumgalleriet Malmö, 1994

7

ALLES GERADE LÜGT. OLIVER ZYBOK

Die Malerei war lange Zeit durch Kriterien und Ideologien, unter denen künstlerische Positionen subsumiert wurden, eingegrenzt. Abstraktion und Gegenständlichkeit, Metaphysik und Ratio, Kritik und Affirmation, Autonomie und künstlerischer Eingriff markierten unversöhnliche, dogmatisch und ideologisch besetzte Gegensätze. Dieses ästhetisch-dialektische Law-and-order-Prinzip stand von Anfang an auf einem instabilen Fundament. Denn wo immer es mediale Grenzen aufwies, lag die Versuchung ihrer Überschreitung nahe. In der Malerei der Gegenwart ist das kategorische Denken im Hinblick auf mediale Eingrenzungen und Materialauswahl weitestgehend überwunden. Sie zeichnet sich durch intermediale Eigenschaften aus und offenbart sich nicht mehr als Feld zwingender Alternativ-Entscheidungen, die dogmatische Bekenntnisse abverlangen. Malerei präsentiert sich heute als Medium, aus dessen historischem Fundus vorurteilsfrei geschöpft werden darf, unabhängig ob es sich dabei um Material, Technik, Motiv, Stil, Inhalt, Form oder Medienüberschreitung handelt. Der in Berlin lebende finnische Künstler Robert Lucander nutzt diese vielfältigen Möglichkeiten. Holz als Untergrund, unter Einbeziehung des zeichnerischen Charakters seiner Maserung, und Lack für den Farbauftrag sind dabei die eher untypischen Materialien für seine Malerei.

Lucanders Arbeiten sind geprägt von einer »Präzision des Ungenauen«, das heißt von einem dialektischen Aspekt, der in seinen frühen, an geometrischen Prinzipien orientierten Arbeiten bis 1994 besonders zum Vorschein kommt. In seinen Überlegungen zum Konstruktivismus der Moderne, für den unter anderen stellvertretend Kasimir Malewitsch und Piet Mondrian stehen, lassen sich Parallelen zu Blinky Palermo erkennen. Ähnlich wie sein 1977 früh verstorbener Kollege ist auch Lucander von der Vergeblichkeit überzeugt, mit Hilfe rationaler Systeme die Welt erfassen zu können, ebenso von der Unterlegenheit jedes auf Perfektion zielenden Gedankens gegenüber der Eigengesetzlichkeit der Natur. Er zweifelt an den Theorien der Moderne und reagiert mit Ironie auf konstruktivistische Gesetzmäßigkeiten, indem er in seinen Bildern gerade das Unregelmäßige, Individuelle und Fragmentarische herausstellt. Malewitsch hatte zwar mit dem Suprematismus theoretisch eine Basis für diese Haltung geschaffen, sich in seiner künstlerischen Ausdrucksweise aber weiterhin einer strengen Geometrie verpflichtet gefühlt, auch wenn seine Werke häufig asymmetrischen Kriterien unterworfen sind. »[D]as Element des Suprematismus ist [...] von jeder sozialen oder sonstigen materialistischen Tendenz frei. Es wäre doch wohl die höchste Zeit einzusehen, daß die Probleme der Kunst und die des Magens und der Vernunft weit auseinanderliegen.«[1] Wenn sich der Verstand, so Malewitsch, in Kausalzwängen bewegt und die Gesetze einer utilitaristischen, realen Praxis formuliert, kann er nicht kreativ wirken. Die Emotion dagegen setzt die schöpferischen Kräfte frei und

EVERYTHING STRAIGHT LIES. OLIVER ZYBOK

Painting was for a long time limited by criteria and ideologies that subsumed artistic positions. Abstraction and representation, metaphysics and reason, criticism and affirmation, autonomy and artistic intervention characterized irreconcilable, dogmatic, and ideologically laden opposites. This aesthetic-dialectic principle of law and order was based on an unstable foundation right from the beginning, for wherever there were media boundaries, there was also the temptation to transgress those boundaries. Categorical thinking has been largely overcome in contemporary painting—at least as far as these media boundaries and the selection of materials are concerned. Nowadays, painting is remarkable for its intermedia characteristics and is no longer considered a place that demands either-or decisions or dogmatic adherence to one particular path. Painting today is a medium whose historical resources can be drawn on without prejudice—regardless of whether they concern material, technique, motif, style, content, form, or intermedia combinations. Finnish artist Robert Lucander, now resident in Berlin, takes advantage of these manifold opportunities. Wood panels, the grain of which is then incorporated into the composition, and enamel paint are just some of the rather untypical materials used in Lucander's paintings.

Lucander's works are marked by a "precision of inexactitude," meaning a dialectic aspect that is particularly noticeable in his early works (up to 1994) based on geometric principles. In his ideas about Constructivism, as represented by Kasimir Malevich and Piet Mondrian, among others, it is possible to see parallels to Blinky Palermo. Like his prematurely deceased colleague (Palermo died in 1977), Lucander is also convinced of the futility of attempting to understand the world through rational systems as well as of the inferiority of all perfection-oriented thinking as opposed to the autonomous laws of nature. He questions modern theories and reacts with irony to Constructivist laws by emphasizing the irregular, the individual, and the fragmentary in his paintings. Although with Suprematism, Malevich created a theoretical basis for this attitude, as an artist he remained bound by the rigors of geometry, even if his works were often subjected to asymmetrical criteria. "The element of Suprematism is ... free of any social—or other—materialistic tendency. It is of course high time we saw that the problems of art and those of the stomach and of the mind are very far apart."[1] According to Malevich, when the mind is constricted by causality and formulates laws for real, utilitarian practice, it cannot be creative. Emotion, on the other hand, liberates our creative powers and, "in a state of supremacy," eliminates all "differences in value, all prerogatives, and all possibilities of comparison" that constantly attempt

eliminiert »im Zustand der Suprematie« alle »Wertunterschiede, Vorrechte und Vergleichsmöglichkeiten«, die ihr der »messende Verstand« permanent aufzwingen möchte.[2] In der konzeptuellen Umsetzung seiner Malerei spielte für Lucander seit Ende der 1980er Jahre, wie auch bei Palermo, der Bezug zum Raum eine wichtige Rolle. Einen direkten Verweis bietet seine Arbeit *das gab es früher schon,* aus dem Jahr 1993, ausgeführt in Lack auf Holz (Abb. S. 17). Dieses Werk rekurriert auf Palermos Gemälde *Straight* von 1965. Es scheint ein lakonischer Kommentar zu einer ironischen Vorlage zu sein, die sich ihrerseits auf kunsthistorische Vorbilder bezieht, auf *New York City* (1942) und auf *Broadway Boogie Woogie* (1942/43) von Mondrian. Palermo unterwandert dessen Ordnungsmuster. In *Straight* überlagern 38 vertikal verlaufende schmale Farbstreifen in Rot, Blau und Gelb 32 ebenso schmale Horizontalbänder, die sich aus wechselnd roten, blauen und gelben Farbquadraten zusammensetzen. Beide Farbrichtungen verweben sich zu einem rektangulären Gittergeflecht, das die rechteckige Bildfläche in einem nichthierarchischen All-over überzieht, sich aber vor einer weißen Grundierung abhebt. Bei längerem Hinsehen wird deutlich, dass sich die Komposition nicht durchgängig an die Regelhaftigkeit des als streng vermuteten Musters hält und vielmehr Regelverletzungen zu erkennen sind. Der äußerste linke Randstreifen wirkt zum Beispiel im Vergleich zu den anderen Vertikalbändern verkümmert. Außerdem sind der 16. Senkrechtstreifen – rot statt gelb – und der 17. – gelb statt rot – vertauscht. Natürlich kann eine solche Beobachtung nur unter der Voraussetzung als Systemstörung gelten, dass es eine Regel gibt, die die farbliche Abfolge von jeweils einem roten, einem blauen und einem gelben Farbstreifen vorschreibt. Doch die Erwartungen an ein perfektes Rastersystem werden weiter unterlaufen: Auch bei der Reihung der waagerechten Farbkästchen handelt es sich keineswegs um eine ordentliche, sondern um eine zufällige Verkettung. Die anfänglichen Erwartungen an Palermos Bild, es mit einem Blick erfassen zu können, werden unterlaufen. So »straight«, wie das Bild vorgibt zu sein, ist es nicht.[3]

In Lucanders Arbeit *das gab es früher schon* überziehen 35 vertikale Farblinien 50 horizontal verlaufende, ebenfalls in Gelb, Rot und Blau auf weißem Grund. Im Gegensatz zu Palermos Arbeit überlagern sich die einzelnen farblichen Raster. Während dieser den Betrachter subtil täuscht, bricht Lucander die Geradlinigkeit der Geometrie auf den ersten Blick. Die Linien sind vom Bildrand mit einer Gießkanne auf den Holzuntergrund gegossen worden, sodass sie zum Teil sehr unregelmäßig verlaufen. Die sich aus den Rasterformationen ergebenden Vierecke sind verschieden groß. Starke perspektivische Verzerrungen werden am linken Bildrand deutlich – einzelne blaue Linien laufen nach oben aus – und an der unteren Bildkante rechts – die blauen Linien brechen nach links

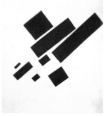

Kasimir Malewitsch,
*Suprematistisches Gemälde:
Acht Rote Rechtecke,* 1915

to apply the "intellectual yardstick."[2] As they did for Palermo, spatial relationships have played an important role in the conceptual realization of Lucander's paintings since the late 1980s. A direct reference to Palermo can be found in his 1993 painting, *das gab es früher schon* (it's been done before), a work in enamel paint on wood (fig. p. 17) that refers to Palermo's own 1965 painting, *Straight.* Lucander's work is a pithy comment on its ironic model, which in turn draws on earlier works of art, namely on Mondrian's *New York City* (1942) and *Broadway Boogie Woogie* (1942–43). Palermo subverts his orderly pattern. In *Straight,* thirty-eight narrow vertical stripes in a sequence of red, blue, and yellow overlap thirty-two equally narrow horizontal stripes made up of alternating red, blue, and yellow rectangles. Both are woven into a rectangular grid, which covers the rectangular surface of the painting in a non-hierarchical all-over, but is nonetheless clearly distinguishable from the white background. On closer inspection, it is evident that the composition does not sustain the regularity of the seemingly strict pattern; violations of the rules become recognizable. The stripe on the far right edge, for example, seems withered in comparison to the other vertical stripes. Furthermore, the sixteenth vertical stripe (red instead of yellow) has been switched with the seventeenth (yellow instead of red). Such an observation, of course, can count as a disturbance in the system only if we assume that there is a rule proscribing a color sequence of red, blue, and yellow. Yet our expectations of a perfectly patterned system continue to be subverted: The row of horizontal boxes does not form an orderly chain, but a random one. The initial expectation that Palermo's painting can be understood at a glance is subverted. As "straight" as the picture seems to be, it is not.[3]

In Lucander's work, *das gab es früher schon,* thirty-five vertical colored lines cross fifty horizontal yellow, red, and blue stripes on a white background. In contrast to Palermo's work, the individual color patterns overlap. Whereas these are subtly deceptive, the way that Lucander breaks up the straightness of the geometry is immediately obvious to the viewer. Starting at the edge of the painting, the lines were poured onto the wooden foundation with a watering can so that in some cases they are very irregular indeed. The rectangles resulting from this grid pattern vary in size. Strong perspectival distortions become apparent on the left edge of the painting and single blue lines run upward and out, while the blue and red lines on the lower right edge veer out to the left and right respectively. Lucander, like Palermo, reverses the sequence of colors, too, swapping the colors red and blue in the thirty-second and thirty-third horizontal lines. The first blue vertical line and last horizontal line wither away. Even stronger are

aus, die roten nach rechts. Wie Palermo hat auch Lucander die Farbreihenfolge vertauscht: bei der 32. und 33. waagerechten Linie, die Farben Rot und Blau. Die erste blaue Linie der Vertikalen und die letzte auf der Horizontalen sind verkümmert. Die geometrischen Verzerrungen werden in dem Pendant dieser Arbeit, *geradeaus,* noch einmal verstärkt (Abb. S. 17). Nach dem gleichen Schema ist hier nur ein einziges blaues Gitterraster aufgezogen, dessen Linienführung noch extremere Ausläufer aufweist als bei *das gab es früher schon.* Beide Arbeiten werden auf dem Boden an der Wand lehnend präsentiert, also eher wie eine Skulptur als wie ein Gemälde. Sowohl die Verwendung von Lack als auch die raumbezogenen, skulpturalen Bezüge verstärken die antimalerische Auffassung. Diese findet in zwei temporären Arbeiten aus dem Jahr 1994 ihren deutlichsten Ausdruck: In der Forumgalleriet in Malmö stellte Lucander einen Topf mit roter Farbe in den Raum und trat ihn um, sodass die Farbe unkontrolliert in den Raum floss. Das Resultat *Probably the Best Red Painting in the World* mit seinen Farbverläufen und Drippings kann durchaus als lapidarer Kommentar zu der Aktionsmalerei von Yves Klein, Morris Louis und Jackson Pollock verstanden werden (Abb. S. 7). Die gleiche Aktion wurde in den Kunst-Werken in Berlin mit einem Topf mit blauer Farbe wiederholt: *Probably the Best Blue Painting in the World.* Malerei ist bei Lucander zu einer plastischen Angelegenheit geworden.

Als Skizzen für seine geometrischen Experimente bezeichnet Lucander die Arrangements mit Blei- und verschiedenfarbigen Buntstiften, die er auf Blöcken oder Schulheftseiten zu einem Raster oder Linienkombinationen zusammengesetzt hat (Abb. S. 20). Ähnlich sind die »temporären« Skizzen im urbanen Raum zu verstehen, die er während seines New-York-Aufenthalts 1994 in Manhattan auf der Straße ausführte (Abb. S. 21). Hier arrangierte er einen oder mehrere Blei- beziehungsweise Buntstifte in der Art, dass sie markante architektonische oder urbane Details in ihren geometrischen Ausformungen betonten. Der in dieser Aktion durch die Wiederholung von Grundmustern angelegte Aspekt des Seriellen sollte Lucander in einer kurzen Schaffensperiode intensiver verfolgen. In dieser Phase sammelte er Vinylplatten (Abb. S. 26/27). Das Hauptaugenmerk war auf die Plattenhüllen und Labels gerichtet. Er reproduzierte zunächst die Schallplatten im gleichen Format als dunkel gefärbte, in der Mitte gelochte Plexiglasscheiben. Danach bearbeitete er ein kreisrundes Papier in der gleichen Größe, wobei er von den Labelvorlagen nur die geometrischen Variationen und monochromen Flächen übernommen hat, ohne den Text im Detail zu berücksichtigen. Um den Konturen eine Unschärfe zu geben, hat er das kreisrunde Papier durch das Bubblejet-Kopierverfahren auf die eigentliche Labelgröße verkleinert. Auch bei den selbst hergestellten Plattenhüllen richtete Lucander seine Konzentration auf geometrische Kompositionen, auf Linienkombinationen

Blinky Palermo,
Straight, 1965

the geometrical distortions in the work's pendant, *geradeaus* (straight ahead, fig. p. 17). Following the same pattern, this work consists of a single blue grid, whose lines branch off even more wildly than the ones in *das gab es früher schon.* Both works are presented leaning against a wall, more like a sculpture than a painting, an anti-painterly attitude that is reinforced by the use of enamel paint and the work's spatial, sculptural properties. This is most clearly expressed in two temporary works done in 1994: In the Forumgalleriet in Malmö, Lucander set up a pot containing red paint and then kicked it over so that the paint flowed out uncontrollably. With its rivers of color and drippings, the result, *Probably the Best Red Painting in the World,* can certainly be regarded as a casual comment on the action paintings of Yves Klein, Morris Louis, and Jackson Pollock (fig. p. 7). The same action was repeated at the Kunst-Werke in Berlin with a pot of blue paint and produced *Probably the Best Blue Painting in the World.* For Lucander, painting has become a sculptural affair.

What Lucander himself calls sketches for his geometric experiments are actually pencils and colored crayons arranged in a grid or a combination of lines on a page in an exercise book or drawing pad (fig. p. 20). The "temporary" sketches he created on the streets of Manhattan during a 1994 stay in New York (fig. p. 21) are similar. In this case, the artist arranged one or more pencils and colored crayons so that their geometrical shapes emphasized particular details of the architectural or urban environment in which they were situated. The serialism implicit in this repetition of basic patterns was something Lucander would pursue more intensively in one particularly brief creative period. During this phase, he collected vinyl albums (fig. p. 26/27), focusing his attention on their covers and labels. His first step was to reproduce the records in the same format as dark Plexiglas discs with holes in the center. He then worked with a round piece of paper of the same size, but adopted only the geometrical variations and monochromatic surfaces of the labels, leaving out the details of the text. In order to blur the contours, he then used a bubble-jet copier to reduce the size of the paper to actual label size. For the record covers, too, Lucander concentrated on the geometric compositions, combinations of lines, and monochromatic surfaces. Here, too, the text was left out, so that ultimately, none of these reproduced, unusable records could be identified either by musician or label. As such a project could not be complete without the record players themselves, of course, Lucander also produced small canvases depicting geometrical equivalents of diaphragms, turntables, pickup arms, needle cartridges, buttons, and switches (fig. p. 26).

und monochrome Flächen. Der Text bleibt hier ebenso ausgespart, sodass am Ende bei der reproduzierten, unbrauchbaren Platte keine genaue Identifizierung möglich ist, weder im Hinblick auf den Interpreten noch auf den Vertrieb. Natürlich durften bei derartigen Realisierungen auch die Abspielgeräte nicht fehlen. Auf kleinformatigen Leinwänden werden die geometrischen Varianten von Membranen, Plattenteller, Tonarm und Tonabnehmer sowie Knöpfe und Schalter wiedergegeben (Abb. S. 26).

Robert Lucander,
das gab es früher schon, 1993

Ab 1996 folgte eine Zäsur im motivischen Repertoire. Lucanders Interesse galt von nun an dem menschlichen Körper, vor allem dem Gesicht in seinen zahlreichen emotionalen Facetten. Seine Motive entnimmt er weiterhin Plattencovern, aber auch Boulevardzeitschriften, Magazinen oder Groschenromanen. Es handelt sich bei den Dargestellten meist um Menschen aus dem öffentlichen Leben: Politiker wie Vladimir Putin und Gerhard Schröder, diverse Supermodels wie Naomi Campbell oder auch Sportler wie Boris Becker und Stefan Effenberg. »[W]enn man genauer hinsieht, fällt auf, dass diese Glamourzeitschriftmenschen einfach so lachen. Es gibt keinen Grund. Was sind das für Menschen, die über alles lachen? Wenn ich etwas Lustiges sehe, dann lache ich, aber ich kann nicht den ganzen Tag lachen. Und diese Menschen lachen immer, das hat etwas Absurdes und Skurriles, deshalb habe ich sie gemalt. Ich habe die Lächerlichkeit dessen abgebildet.«[4] Lucander interessiert die Entwicklung der Darstellungskonventionen, die in massenmedial verwendeten Bildern ablesbar sind, da diese Phänomene eine Zeit repräsentieren. Seine Herangehensweise erinnert an eine kurze Schaffensperiode von Francis Picabia von circa 1939 bis 1944, in der dessen Gemälde fotorealistische Züge annehmen. Offensichtlich arbeitete Picabia mit Fotos aus Büchern, Zeitschriften und seinem Privatarchiv. Dem *Autoportrait* (um 1940) lag zum Beispiel eine von seiner späteren Frau Olga Mohler aufgenommene Fotografie aus den 1930er Jahren zugrunde. Kennzeichnend für diese Zeit sind die erotischen, fast fotorealistischen Gemälde Picabias, die sogenannten »Kitsch-Bilder« wie *Femme à l'idole* (1940/41) oder *Femme au bulldog* (1940/42). In Pose und Darstellung lassen die Frauengestalten oft keinen Zweifel über ihre Herkunft. Sie sind Abbildungen aus Filmzeitschriften entlehnt. Daher stammt das eigenartige Licht auf diesen Bildern, eine Beleuchtung für Dreharbeiten, die in die Malerei eine seltsame Distanziertheit hineinträgt. Hier wird das Artifizielle der filmischen Bildkomposition sichtbar.[5] Einen ähnlichen Charakter entfalten auch Lucanders Porträts. Dabei dient die Maserung des Holzes als kompositorisches Element. Die Kunsthistorikerin Melitta Kliege hat die Arbeitsweise treffend beschrieben: Lucander bearbeitet Sperrholzplatten in zwei Verfahren. »Zum einen zeichnet er mit Bleistift und Buntstift direkt auf die Holzoberfläche, die abschließend mit Klarlack überzogen wird, wodurch die Maserung des Holzes sichtbar

1996 saw a change in Lucander's repertoire of motifs. From that point on, his interest was focused on the human body, especially the face in all its many emotional facets. While he continued to employ motifs from record covers, he also plundered the tabloid press, magazines, and cheap novels. Most of the people portrayed were public figures: politicians such as Vladimir Putin and Gerhard Schröder, diverse supermodels like Naomi Campbell, or sports celebrities such as Boris Becker and Stefan Effenberg. "If you take a closer look, you'll notice that people in glamour magazines are always laughing, but for no apparent reason. What kind of people laugh at anything and everything? If I see something funny, then I laugh, but I can't spend the whole day laughing. And these people are laughing all the time. There's something absurd and comical about that, which is why I painted them. I've depicted their silliness."[4] Lucander is interested in the development of the portraiture conventions visible in mass media images, since these phenomena represent a particular era. His approach recalls a brief period in the career of Francis Picabia, whose paintings from around 1939 to 1944 took on photorealistic qualities. Picabia was obviously working with photographs from books, magazines, and his own private archives. His *Autoportrait* (circa 1940), for instance, was based on a photograph taken in the thirties by his future wife, Olga Mohler. Picabia's erotic, almost photorealistic paintings, the so-called "kitsch paintings" such as *Femme à l'idole* (1940/41) or *Femme au bulldog* (1940–42) were characteristic of this time. The way they are posed and portrayed often leaves no doubt that these female figures have come straight out of movie magazines. This also explains the peculiar light in these paintings: It is the kind of light that is used in filmmaking, but that when used in painting creates a sense of distance. Here, the artificiality of cinematic composition is rendered visible.[5] Lucander's portraits reveal a similarly artificial character. The wood grain serves as a compositional element. Art historian Melitta Kliege has described how Lucander treats his plywood boards in two operations: "In the first process, he draws directly on the surface of the wood with pencil and colored crayon. The board is then covered with a layer of transparent lacquer, which allows the wood grain to remain visible. In the second process, he first primes the board and then coats it with emulsion paint, never mixing his paints as a rule and using only a few colors over large areas of the panel. While the drawings create different volumes, the painted surfaces have no structure at all. The only form they have comes from their outline, which is sometimes highlighted by a white stripe."[6] Body language, facial expressions, and gestures are of primary importance. "The visual composition," as Kliege continues, "is divided into three levels: first, the monochrome background behind the figures, second, their clothing and hair, the details of which remain

bleibt. Zum anderen grundiert er die Tafel zunächst und bemalt sie dann mit Dispersionslack – typisch ist, daß er die Farben niemals mischt und nur wenige Töne großflächig einsetzt. Während die Zeichnung Volumen schafft, sind die gemalten Flächen strukturlos; eine Form erhalten sie einzig durch ihren Umriß, der manchmal mit einem weißen Streifen abgesetzt wird.«[6] Gebärden, Mimik und Geste stehen im Vordergrund. »Dabei ist der Bildaufbau«, so Kliege weiter, »durch drei Ebenen gegliedert: Erstens der monochrome Hintergrund, vor dem die Figuren stehen; zweitens die Kleidung wie die Haare der Personen, die im Schema der Fläche erkennbar bleiben, und drittens die unbekleideten Partien des Menschen (Gesichter, Hände, Arme und Beine), die durch die Zeichnung räumlich dargestellt sind und durch die Holzmaserung strukturiert werden.«[7] Lucander verwendet einige Motive mehrmals, oft indem er sie entweder farblich anders nuanciert oder spiegelverkehrt variiert, wie bei *Begeisterte Zurufe vom Straßenrand* und *Aber ich habe das immer schon gewusst von der, weil die nicht gerade schaut, immer so vorbei ...* (beide 2000). Für den Betrachter zeigt sich, wie verschieden unter anderen Gegebenheiten gleiche Gesten und Gebärden wahrgenommen werden.

In diesen Arbeiten ist immer noch, wenn auch nicht vordergründig, der geometrische Aspekt von Bedeutung. Die in den Vorlagen massenhaft reproduzierten Personen repräsentieren von der Gesellschaft zugewiesene Rollen. Diese sind häufig durch ein Schönheitsideal geprägt, das von der Kosmetikindustrie und Schönheitschirurgie propagiert wird. Die Idealvorstellung zeigt sich auf Grundlage variationsreicher geometrischer Muster, die in Vorstufen bereits seit dem 16. Jahrhundert wirkungsmächtig sind. In seinem posthum erschienenen Werk *Über den natürlichen Unterschied der Gesichtszüge in Menschen verschiedener Gegenden und verschiedenen Alters. [...]* (1791) vertritt Petrus Camper zum Beispiel ein klassizistisches Schönheitsideal. Wie dieses nun auch konstruktiv kontrollierbar ist, belegt er mit dem nach ihm benannten »Gesichtswinkel«.[8] Derartige Untersuchungen haben sich jeweils in wissenschaftlich aktualisierter Form über die Phrenologie und Kraniologie bis in die Schönheitschirurgie und Gentechnik hinein erhalten. Lucander durchbricht mit seinen Blei- und Buntstiftschraffuren und der Einbindung der zufällig angeordneten Holzmaserungen diese geometrisch geprägten, physiognomischen Idealvorstellungen, die sich zum Teil in seinen Vorlagen widerspiegeln. Gesteigert wird diese Art der Fragmentierung seit 2003, als der Künstler die Gemälde entweder nach der Grundierung, im Anfangsstadium des Schaffensprozesses, oder im vollendeten, aber noch nicht getrockneten Zustand über den verschmutzten Atelierboden zieht, sodass unter anderem Kratzspuren von Granulat die Oberfläche überziehen. Die Farbigkeit wird gebrochen und die einzelnen Flächen sind nicht mehr homogen. Lucander bezeichnet diesen Vorgang als eine »Ästhetik von

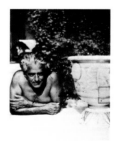

Francis Picabia im I at the Chateau de Mai, Mougins, circa 1934

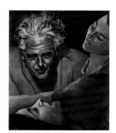

Francis Picabia, *Autoportrait,* circa 1940

sketchily apparent in the surface pattern, and third, the unclothed body parts (faces, hands, arms, and legs), which acquire volume through being drawn and structure from the grain of the wood."[7] Lucander uses some motifs over and over again, often by varying the nuances of color or reversing them, as can be seen in *Begeisterte Zurufe vom Straßenrand* (Excited call from the curbside) and *Aber ich habe das immer schon gewusst von der, weil die nicht gerade schaut, immer so vorbei ...* (But I always knew that about her, because she didn't look straight ahead, always beyond ..., both 2000). To the viewer it soon becomes clear that the same gestures and body language can be perceived very differently under different circumstances.

In these works, the geometric aspect is still significant, although no longer the main emphasis. The mass reproduced people in the original photographs represent roles assigned by society. They are often characterized by an ideal of beauty propagated by the cosmetics and cosmetic surgery industries—an ideal based on a huge variety of geometrical patterns, the antecedents of which have been having an impact ever since the sixteenth century. In his posthumously published work, *Über den natürlichen Unterschied der Gesichtszüge in Menschen verschiedener Gegenden und verschiedenen Alters. ...* (On Natural Difference in the Facial Features of People of Different Regions and Different Ages. ..., 1791), Petrus Camper, for instance, presented a Classicist ideal of beauty, proving how it could be constructively controlled with what he called the "facial angle."[8] This line of inquiry has its descendents in modern science, having progressed from phrenology and craniology to cosmetic surgery and genetic technology. With his pencil and crayon hatching and the incorporation of the randomly patterned wood grain, Lucander breaks through these geometrically influenced, idealized notions of physiognomy, some of which are reflected in his models. This kind of fragmentation increased after 2003, when the artist began taking paintings at a particular stage—either after priming and hence at the beginning of the creative process, or in its final stages, when the painting was finished, but not yet dry—and dragging them across the dirty floor of his studio, so that the surface became covered in grainy scratches, the color fragmented and the various planes no longer homogeneous. Lucander describes this process as the "aesthetic of anonymous vandalism,"[9] which is expressed in general in his characteristically anti-painterly attitude, and which here is taken to the extreme. In *Da beisst die Maus kein' Faden ab* (The mouse won't bite off a thread, fig. p. 66), the method is used to distort the facial expressions of two young women, who at first glance could certainly be thought to represent the current ideal of youthful beauty. This motif is the first personal photograph—

anonymem Vandalismus«,[9] die sich insgesamt in der für ihn charakteristischen antimalerischen Haltung äußert und hier in einer gesteigerten Ausformulierung zuspitzt. In der Arbeit *Da beisst die Maus kein' Faden ab* (Abb. S. 66) werden die Gesichtszüge zweier junger Frauen, die auf den ersten Blick durchaus einem jugendlichen Schönheitsideal der Zeit entsprechen könnten, durch diese Methode verfremdet. Das Motiv ist die erste persönliche Fotografie, die in Lucanders Arbeit als Vorlage Verwendung findet, aufgenommen bei einem Konzert des Hiphop-Stars Eminem in Hamburg. Ein weiteres Novum in diesem Werk, das sich auch in anderen Gemälden seit 2003 finden lässt, zeigt sich in der veränderten Darstellung der Kleidung. Sie wird nicht mehr durch eine monochrome Farbgebung repräsentiert, sondern durch detailreiche Ausarbeitungen. Die Kleidung in den Gemälden stimmt dabei meistens nicht mit der der Vorlagen überein. So stammt das Muster der mit Sternen überzogenen rot-blau-weißen Jacke der rechten Figur in *Da beisst die Maus kein' Faden ab* aus dem Kleidungssortiment des Künstlers. Als Kleidungsmuster tauchen in diesem Zusammenhang vermehrt geometrische Variationen auf. In dem Werk *Das darf doch nicht wahr sein,* 2005, (Abb. S. 94/95) entlehnt Lucander erneut geometrische Ausführungen von Mondrian, die in den vergangenen Jahren mit Vorliebe in der Werbung und im Interieurbereich verwendet werden, und überträgt sie auf zwei Schürzen, die zwei Frauenfiguren mit erstauntem Gesichtsausdruck zugeordnet sind. Der Frauenkopf auf der linken Bildhälfte ist auf der gegenüberliegenden Seite spiegelverkehrt wiedergegeben. Der weiblichen Gestalt mit ihrem gespiegelten Pendant sind Sprechblasen zugewiesen, die den Titel der Arbeit zitieren – ein neues stilistisches Merkmal in Lucanders Œuvre; einmal lesbar, auf der anderen Hälfte seitenverkehrt. Die Oberfläche, die zum größten Teil von der Holzmaserung dominiert wird, ist durch Schleifspuren und Bleistiftschraffuren gekennzeichnet. Das Gesicht wirkt wie eine Begleitinstanz der sprachlichen Äußerung. Es liegt nicht in der individuellen Besonderheit, sondern in seiner Ausdruckskraft, das heißt der Wirksamkeit seiner eloquenten Chiffrierung begründet.

Die These, dass das Gesicht sprachlich strukturiert und dass es ferner die Grundbedingung einer jeden funktionierenden zwischenmenschlichen Kommunikation sei, schreibt nur vordergründig die Geschichte der Physiognomie fort. Das Gesicht ist nichts Gegebenes, wie Gilles Deleuze und Félix Guattari in ihrem Buch *Tausend Plateaus* (1992) erläutern, sondern realisiert sich immer erst interaktiv im Verhältnis zu einem weiteren. Das individuierte, konkrete Gesicht entsteht also erst durch die Absetzung von einem anderen Gesicht. Es ist folglich nie allein, denn es unterhält notwendig eine Beziehung: das Gesicht der Mutter konstituiert sich in Bezug zu dem des Kindes, das Gesicht des Chefs zu dem seines Angestellten, das Gesicht der Frau zu dem des Mannes et cetera. Die Semiotik des

Petrus Camper,
Über den natürlichen Unterschied der Gesichtszüge in Menschen verschiedener Gegenden und verschiedenen Alters. [...],
Tafel I Plate 3, Berlin 1792

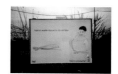

Werbeplakat für ein Kosmetikprodukt I Poster advertising a
cosmetic product,
Berlin-Mitte, 2003

taken at a concert by Hip Hop star Eminem in Hamburg—that Lucander used as a basis for a painting. Another innovation in this work, and one that can be found in other paintings done after 2003, is evident in the changed depiction of clothing, which instead of being represented by a monochromatic plane of color is now full of details. The clothing in the paintings is not usually the same as that in the original photographs. The pattern of the star-strewn red, white, and blue jacket worn by the right-hand figure in *Da beisst die Maus kein' Faden ab,* for example, comes straight out of the artist's own closet. A lot of the patterns used here are variations on geometric themes. For *Das darf doch nicht wahr sein* (That can't be true, 2005, fig. p. 94/95), Lucander once again borrows Mondrian-style geometric patterns that in recent years have become so popular in advertising and interior design. Lucander transfers these onto the aprons worn by two female figures with astonished expressions on their faces. The head of the woman on the left is mirrored on the opposite side of the painting. Both heads are furnished with balloons quoting the title of the work, this representing another addition to Lucander's stylistic palette: One version is legible, while the other is reversed. The surface is to a large extent dominated by the wood grain, but is also scraped in places and marked with pencil hatching. The face appears almost like an adjunct of linguistic expression, an effect that owes more to its expressiveness, meaning to the effectiveness of its eloquent encoding, than to its individuality.

The thesis that the face structures speech and moreover is essential to all functional interpersonal communications is only superficially what the history of physiognomy is about. As Gilles Deleuze and Félix Guattari explain in their book, *Thousand Plateaus* (1992), the face is not a given, but is realized only through interaction with another. A specific, individualized face exists only when it can be distinguished from another face. It is therefore never alone, but has to be in a relationship with another—the mother's face with that of her child, the boss's face with that of his employee, a woman's face with that of a man and so on and so forth. The semiotics of the face, in other words, are shaped by paradigmatic, antithetical pairs. Faces, which are often the expression of power relations, conjure each other up, as is made clear by Lucander's models. Guattari sums up this process of communicative exchange by which faces affect each other as follows: "One countenance answers another countenance. Each and every sensory effect is focused between two deterritorialized, momentary gazes."[10] What follows is selection: Will this specific face be accepted or not? This selection is the "visum,"[11] the stamp that says that the face of the person opposite has a concrete meaning.

Gesichts bildet sich also durch paradigmatische antithetische Paare aus. Die Gesichter – nicht selten Ausdruck von Machtverhältnissen – rufen sich gegenseitig auf, was in Lucanders Vorlagen exemplarisch verdeutlicht wird. Guattari erfasst diesen kommunikativen Austauschprozess, in dem die Gesichter sich wechselseitig bewirken, folgendermaßen: »Eine Gesichtlichkeit antwortet einer anderen Gesichtlichkeit. Jeder Sinneffekt stellt sich ein zwischen zwei deterritorialisierten Augenblicken.«[10] Es folgt eine Selektion, ob ein konkretes Gesicht akzeptiert wird oder nicht. Sie stellt das »Visum«,[11] den Sichtvermerk aus, dass dieses Gesicht dem jeweiligen Gegenüber etwas Konkretes bedeutet.

Das Perfide eines derartigen Gesichterschaffungsprozesses liegt in der scheinbaren Gewinnung des *eigenen* Profils, das die Grundlage für den Glauben an das autonome Subjekt bildet, welches sich befreit weiß aus seiner körperlichen Determiniertheit, jedoch verkennt, dass es Manipulationsstrategien unterliegt. Insofern sind die Vorlagen für Lucanders Gesichtstransformationen von verschiedenen gesellschaftlichen Konventionen abhängig. Ab 2002 erweitert er seinen Fundus an Personendarstellungen auch auf sogenannte Randfiguren der Gesellschaft. Es werden ungeschönte Vorlagen von Obdachlosen, Kriminellen und alten Menschen, die im Gegensatz zu den Prominentendarstellungen keiner Selbstinszenierung unterliegen, ins motivische Repertoire aufgenommen. Lucander spielt mit gesellschaftlichen Klischees und Imagevorstellungen und zeigt in Form von »ungeschönter« Mimik und Gestik in diesen Bildern die Kehrseiten der Gesellschaft. Die determinierende Festschreibung auf ein Sein muss überführt werden in ein Werden, das unvorhergesehene Beziehungen knüpft und Metamorphosen ausbildet, das also den festumrissenen Horizont des einzelnen Gesichts überschreitet: »Es gibt Linien«, so Deleuze, »die eine Kontur bilden, und andere, die keine Kontur bilden. Diese sind am schönsten.«[12] Die Vision eines Ausbruchs aus einem medialen Standardgesicht vollzieht sich über derartige Fluchtlinien, wenn Deleuze und Guattari aus der einzelnen Sommersprosse einen Partikel machen, um hieraus eine Fluchtlinie zu ziehen, die der imaginären Abstammung entkommt.[13] Lucanders Fluchtlinien ergeben sich aus den einzelnen Blei- und Buntstiftschraffuren beziehungsweise aus der Holzmaserung, die den physiognomischen Verlauf des Gesichts auf der Vorlage unterbrechen. Diese Befreiung via Sinnentzug durch scheinbar absurde Verknüpfungen präzisieren Deleuze und Guattari als »Sich auf eine abstrakte Linie, ein Merkmal reduzieren, um seine Zone der Ununterscheidbarkeit von anderen Merkmalen zu finden und so in die Diesheit und Unpersönlichkeit des Subjekts einzutreten [...].«[14]

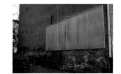

Unbeklebte Plakatwand I
Empty Billboard, Berlin-Mitte,
1991

Beispielhaft für eine derartige Befreiung aus den Fesseln der Repräsentation durch die Deformation des Gesichts ist für Deleuze das Werk Francis Bacons, dessen künstlerische Leistung vor allem darin erkannt wird, »[...] den Kopf unter dem Gesicht wieder

What makes this process of creating a face so perfidious is the apparent acquisition of an individual profile. Such a profile is essential to a belief in the autonomous subject that knows it has been released from physical determinism, yet is unaware of being subject to manipulative strategies. In this regard, the models for Lucander's facial transformations are dependent on various social conventions. Starting in 2002, he expanded his archive of portraits to include the so-called socially marginalized as well. Unlike his celebrity portraits, the homeless people, criminals, and the elderly now included in his repertoire do not pose or seek to present themselves in any particular light. Lucander plays with social clichés and the notion of the image and shows the underbelly of society in the shape of 'unvarnished' faces and gestures. The determinative fixation on being must be transformed into a state of becoming that forms unforeseen relationships, develops metamorphoses and transgresses the delimiting horizon of the individual face. "There are lines," writes Deleuze, "that form a contour, and others that form none at all. Those are the most beautiful."[12] It is lines of perspective such as these that perfect the vision of a breach with the standardized media face—when Deleuze and Guattari, for example, turn a single freckle into a particle, in order to draw from that particle a line of perspective that will escape its imaginary origins.[13] Lucander's lines of perspective grow out of his pencil hatching or the wood grain that interrupts the physiognomic composition of his model's face. This liberation, achieved because meaning is removed through the interjection of apparently absurd connections, is described by Deleuze and Guattari as "reduction to an abstract line or a feature in an attempt to discover that zone in which it cannot be differentiated from other features and so to enter into the thisness and impersonality of the subject … ."[14]

For Deleuze, Francis Bacon's work is an outstanding example of how the chains of representation are broken through the act of deforming the face. Bacon's greatest artistic achievement, according to Deleuze, has been "… to rediscover—or bring to the fore—the head underneath the face."[15] Owing to their almost mischievous exaggeration, Lucander's *Ich als Mensch brauch das nicht* (I as a human being do not need that) or *Die Abenteuer der Wahrnehmung* (The adventure of perception, both 2002) certainly belong to this tradition. His painting in general, however, avoids the classic attitudes of this medium, if only thanks to his choice of materials and the intermedia aspects of his works (fig. p. 63). If the task of "classic" painting (which, according to Deleuze, was above all representative) was primarily to create a visual field for the "figurative coordination of organic represen-

finden oder auftauchen [zu] lassen.«[15] Durch ihre Überzeichnung, die schon etwas Fratzenhaftes offen legt, stehen unter anderen Lucanders Gemälde *Ich als Mensch brauch das nicht* oder *Die Abenteuer der Wahrnehmung* (beide 2002) durchaus in dieser Tradition, obwohl seine Malerei klassische Attitüden dieses Mediums durch die Materialwahl und intermediale Aspekte vermeidet (Abb. S. 63). Lag die Aufgabe der »klassischen« Malerei, die sich nach Deleuze durch ihre repräsentative Funktion auszeichnete, in erster Linie in der Ausbildung eines Gesichtsfeldes, das die »figurative Koordination der organischen Repräsentation«[16] schafft, ist mit ihrer Materialität selbst schon die Möglichkeit der Aufhebung gegeben, die Möglichkeit der Außerkraftsetzung dieser aufs Ganze gehenden Organisation durch ihr subversives Potenzial. »Die Malerei unternimmt es unmittelbar«, so Deleuze, »die Präsenz unterhalb der Repräsentation, hinter der Repräsentation freizusetzen.«[17] Diese Sichtbarmachung des dem Signifikantennetz entgehenden Unsichtbaren – Deleuze zitiert hier Paul Klees programmatische Aussage: »Kunst gibt nicht das Sichtbare wieder, sondern macht sichtbar«[18] – setzt Kräfte frei, die die Gesichtlichkeit aufbrechen, um in diesem Feld einzigartige Intensitätsräume zu eröffnen. Lucander gelingt dies durch die Strategie der Vermeidung. Indem er als zeitgenössischer Maler sich von traditionellen Sujets der Malerei löst und stattdessen für sie untypische Techniken einsetzt, erweitert er das Feld gattungsbestimmter Kriterien. Damit nimmt er eine kritische Haltung gegenüber jeglicher medialer Determiniertheit ein. Lucander entlarvt die Gesichter seiner Vorlagen, hinter denen der Betrachter eine versteckte Erkenntnis erhofft. Doch es gibt kein Jenseits hinter diesen Masken, keinen authentischen Kern, den es zu entdecken gilt. Robert Lucander experimentiert mit den Masken, eröffnet Spielräume und lässt sie »schizo« werden. Er ermöglicht dem Gesicht somit eine nicht von vornherein festgelegte Zukunft.

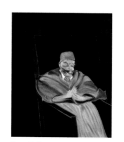

Francis Bacon,
Study for a Pope IV, 1961

Anmerkungen

1 Zit. n. Karin Thomas, *Bis heute: Stilgeschichte der bildenden Kunst im 20. Jahrhundert*, Köln 1988, S. 136. **I 2** Vgl. ebd., S. 134 ff. **I 3** Vgl. hierzu Klaus Schrenk, »Zum künstlerischen Werk von Palermo«, in: Thordis Moeller (Hrsg.), *Palermo. Bilder und Objekte, Werkverzeichnis Band I*, Stuttgart 1995, S. 13–23. **I 4** Robert Lucander. Sven Drühl, »›Man muss nicht nur die schönen Seiten zeigen, es gibt auch andere.‹ Ein Gespräch«, in: *Kunstforum International*, Bd. 174, Januar–März 2005, S. 243 f. **I 5** Auffällig ist auch Picabias Interesse für geometrische Bildzusammenhänge – eine weitere Gemeinsamkeit mit Lucander –, das sich unter anderem in seinen mechanomorphen Arbeiten ab ca. 1915 äußert, denen eine Faszination für die Technik zugrunde liegt. Geometrische Formen und Raster tauchen aber auch im Verlauf der 1920er und 1930er Jahre immer wieder in seinem Œuvre auf und prägen vor allem sein Spätwerk ab 1945. Vgl. hierzu *Francis Picabia*, Ausst.-Kat. Städtische Kunsthalle Düsseldorf; Kunsthaus Zürich; Moderna Museet Stockholm, Köln 1984. **I 6** Melitta Kliege, »Farbwechsel – Die Lackbilder von Robert Lucander«, in: *Robert Lucander. Accatone*, Ausst.-Kat. Contemporary Fine Arts, Berlin, Köln 2000, o. S. **I 7** Ebd. **I 8** Vgl. Oliver Zybok (Hrsg.), *Von Angesicht zu Angesicht. Mimik – Gebärden – Emotionen*, Ausst.-Kat. Städtisches Museum Leverkusen Schloß Morsbroich, Leipzig 2000, S. 104 f. **I 9** Vgl. Lucander, S. 248. **I 10** Félix Guattari, *L'inconscient machinique*, Paris 1979, S. 101. **I 11** Ebd. **I 12** Gilles Deleuze, *Unterhandlungen 1972–1990*, Frankfurt am Main 1990, S. 52. **I 13** Gilles Deleuze und Félix Guattari, *Tausend Plateaus*, Berlin 1992, S. 325. **I 14** Ebd., S. 382. **I 15** Gilles Deleuze, *Francis Bacon. Logik der Sensation*, München 1995, S. 19. **I 16** Ebd., S. 36. **I 17** Ebd. **I 18** Paul Klee, »Schöpferische Konfession«, in: ders., *Schriften*, Köln 1976, S. 118.

tation,"[16] then the subversive potential of its materiality alone would be enough to permit the annulment of this holistic organizing principle. "Painting," writes Deleuze, "seeks directly to liberate the presence underneath or behind the representation."[17] This visualization of those invisibles that have escaped the net of significance (here, Deleuze quotes Paul Klee's programmatic statement: "Art does not reproduce what is visible, it makes things visible,"[18]) sets free forces that break apart the visual field in order to open up unique areas of intensity within it. Lucander succeeds at this through his strategy of avoidance. By detaching himself, as a contemporary painter, from the traditional subjects of painting and instead employing unconventional techniques, he expands the field of genre-specific criteria. This makes him critical of every form of media-controlled determinism. Lucander unmasks his models, only to show that instead of the hidden knowledge the viewer had hoped for, there is nothing behind the mask at all—no authentic core to be discovered. Lucander experiments with these masks, plays with them and allows them to become 'schizo.' In doing so, he provides the face with a genuinely unpredestined future.

Robert Lucander,
*Die Abenteuer der Wahr-
nehmung,* 2002

Notes

1 Quoted in Karin Thomas, *Bis heute: Stilgeschichte der bildenden Kunst im 20. Jahrhundert*, (Cologne, 1988), p. 136. **I 2** See Thomas, pp. 134ff. **I 3** For more on this, see Klaus Schrenk, "Zum künstlerischen Werk von Palermo", *Palermo. Bilder und Objekte, Werkverzeichnis Band I*, Thordis Moeller (ed.). (Stuttgart, 1995), pp. 13–23. **I 4** Robert Lucander. Sven Drühl, "'Man muss nicht nur die schönen Seiten zeigen, es gibt auch andere.' Ein Gespräch," *Kunstforum International*. vol. 174 (January/March 2005), pp. 243–244. **I 5** Also remarkable is Picabia's interest in geometric contexts, which is something else he has in common with Lucander. This is evident in the post-1915 mechanomorphic works that grew out of his fascination with technology. Geometric shapes and patterns, however, continued to appear in his oeuvre throughout the 1920s and '30s, and are especially important to his later works from 1945 onwards. For more on this, see *Francis Picabia*, exh. cat., Städtische Kunsthalle Düsseldorf/Kunsthaus Zurich/Moderna Museet (Cologne, 1984). **I 6** Melitta Kliege, "Farbwechsel—Die Lackbilder von Robert Lucander," *Robert Lucander. Accatone*, exh. cat., Contemporary Fine Arts, Berlin (Cologne, 2000), unpaginated. **I 7** Ibid. **I 8** See Oliver Zybok (ed.), *Von Angesicht zu Angesicht. Mimik—Gebärden—Emotionen*, exh. cat., Städtisches Museum Leverkusen Schloß Morsbroich (Leipzig, 2000), pp. 104–105. **I 9** See Lucander, p. 248. **I 10** Félix Guattari, *L'inconscient machinique* (Paris, 1979), p. 101. **I 11** Ibid. **I 12** Gilles Deleuze, *Unterhandlungen 1972–1990* (Frankfurt am Main, 1990), p. 52. **I 13** Gilles Deleuze and Félix Guattari, *Tausend Plateaus* (Berlin, 1992), p. 325. **I 14** Ibid., p. 382. **I 15** Gilles Deleuze, *Francis Bacon. Logik der Sensation* (Munich, 1995), p. 19. **I 16** Ibid., p. 36. **I 17** Ibid. **I 18** Paul Klee, "Schöpferische Konfession," Klee, *Schriften* (Cologne, 1976), p. 118.

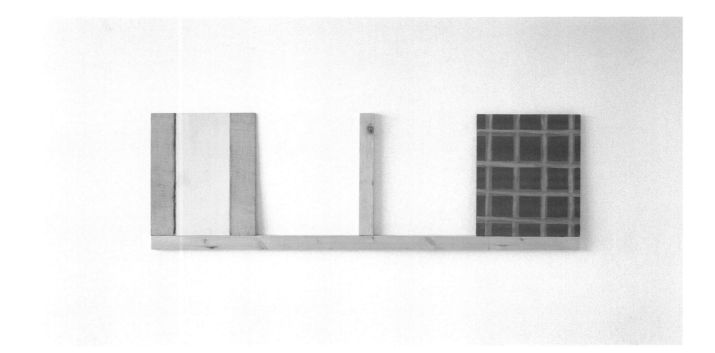

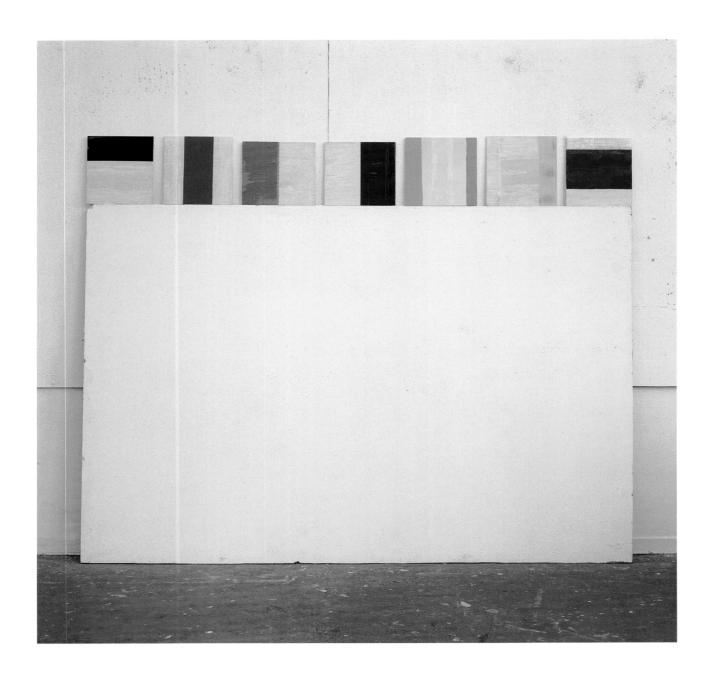

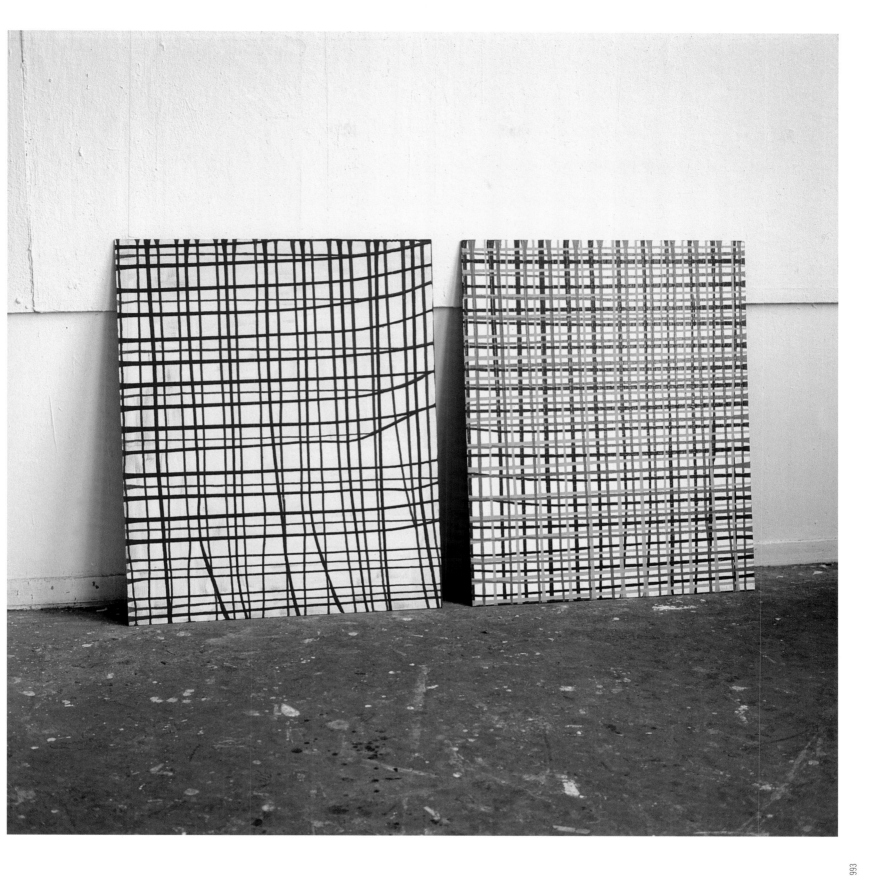

geradeaus, 1993
das gab es früher schon, 1993

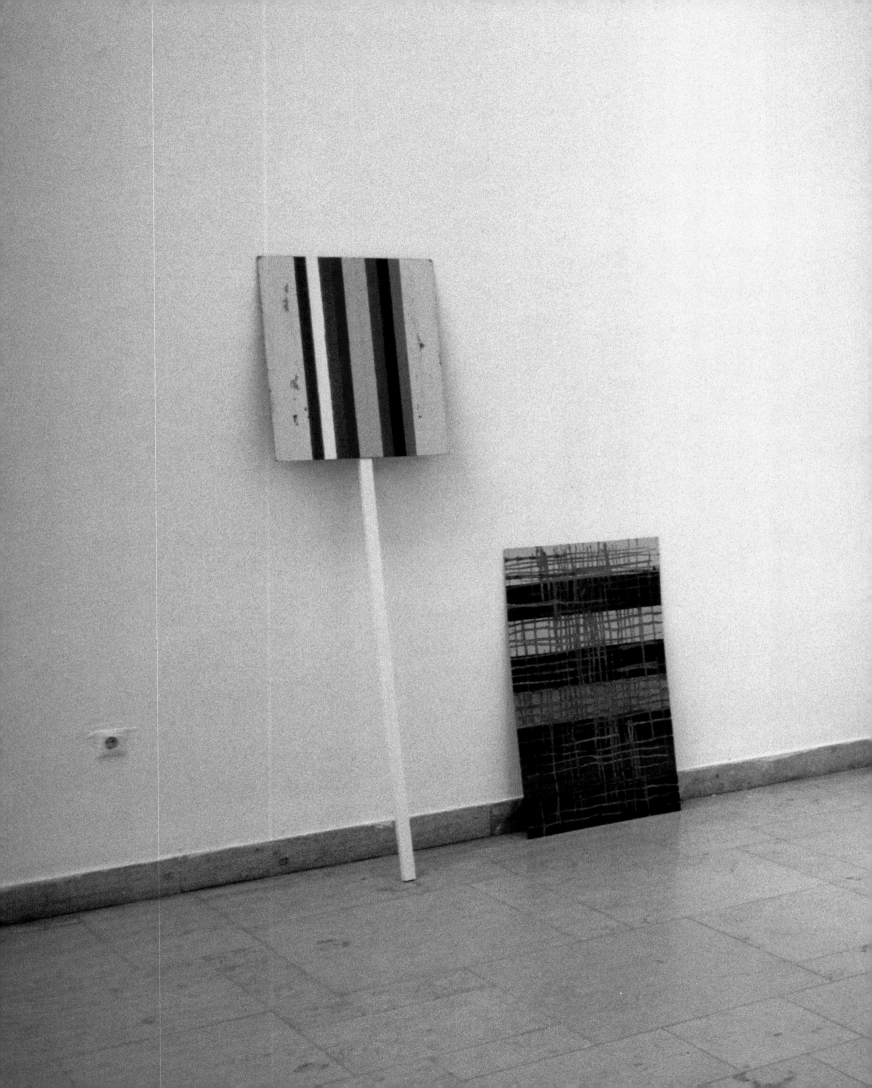

Installationsansicht Hochschule der Künste, Berlin, mit folgenden Werken aus dem Jahr 1993 (v. l. n. r.) |
Photo of installation with the following works from the year 1993 (l to r):
Transparent; Ohne Titel; Kreis & Kreis; Bildobjekt I; Altneu

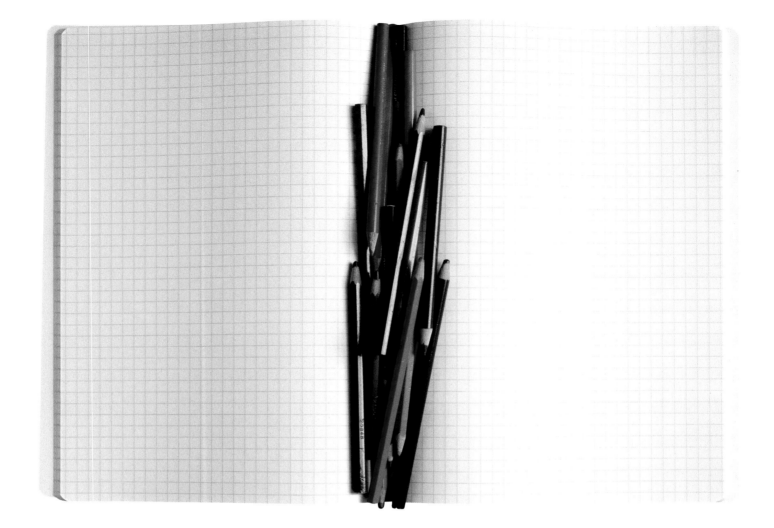

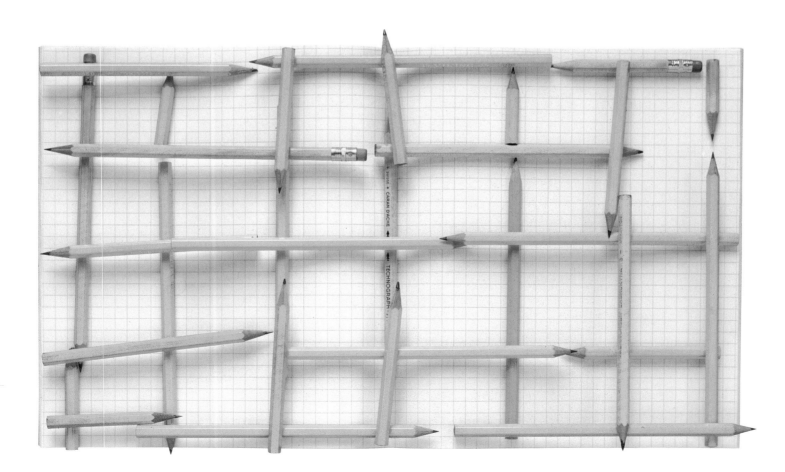

WALTER DE MARIA
THE BROKEN KILOMETER

HOURS: WED-SAT.12-6
393 WEST BROADWAY
DIA CENTER FOR THE ART

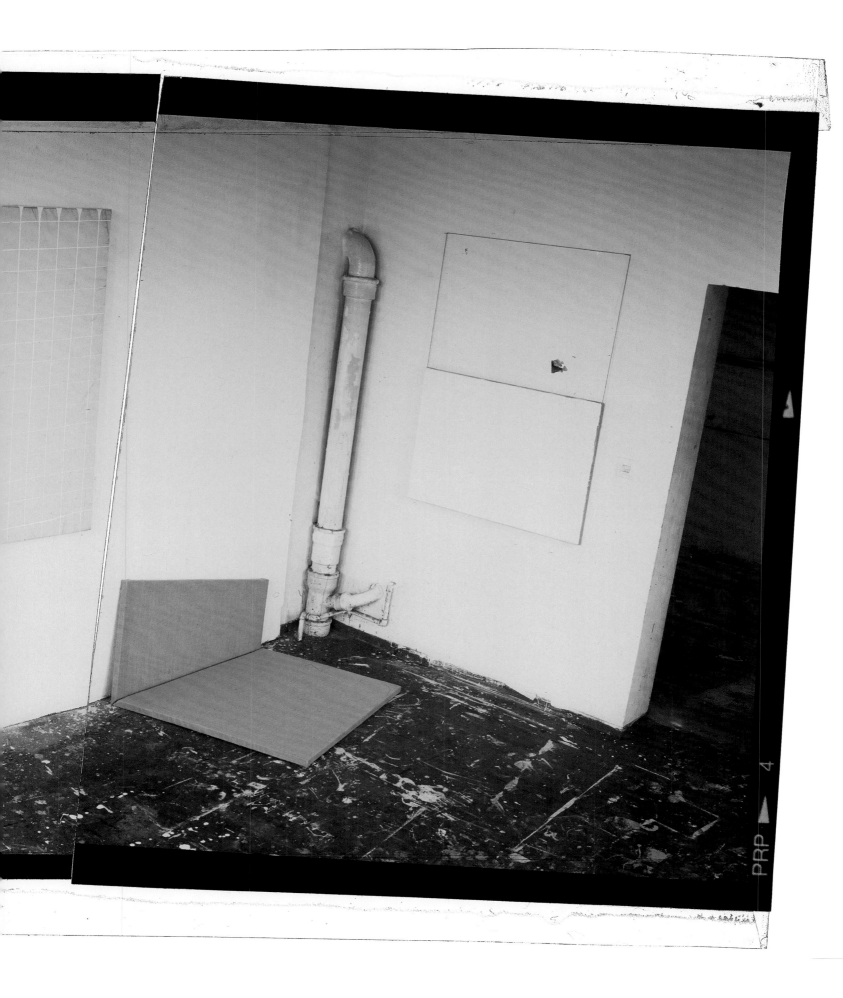

23

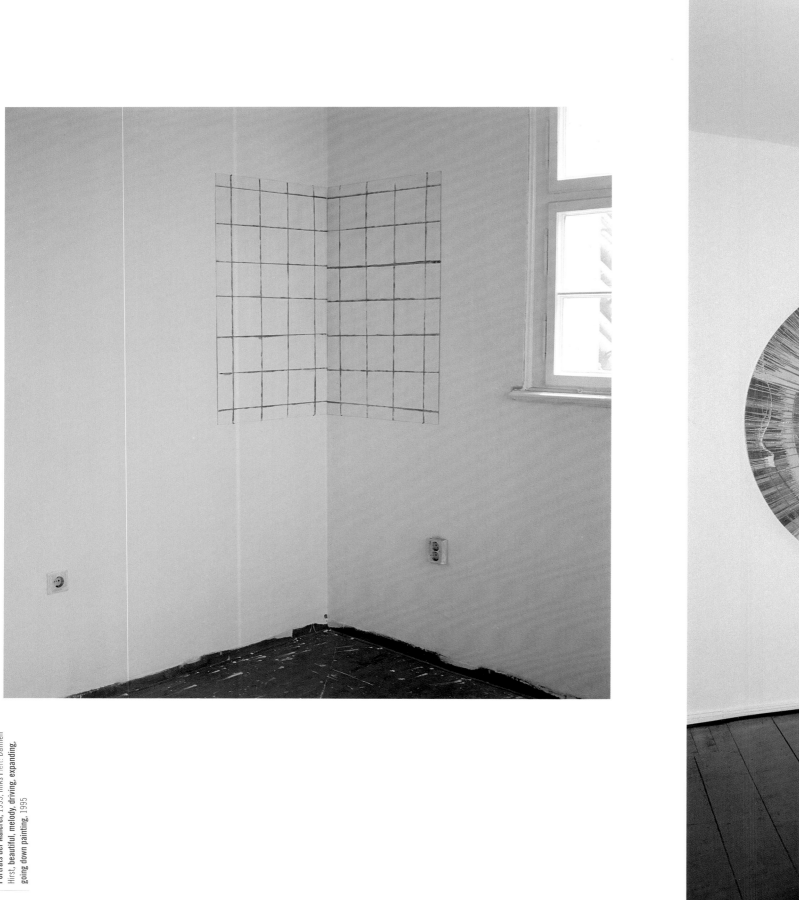

So ist es immer. 1995
Porträts der Malerei. 1995, links I left: Damien
Hirst, **beautiful, melody, driving, expanding,**
going down painting. 1995

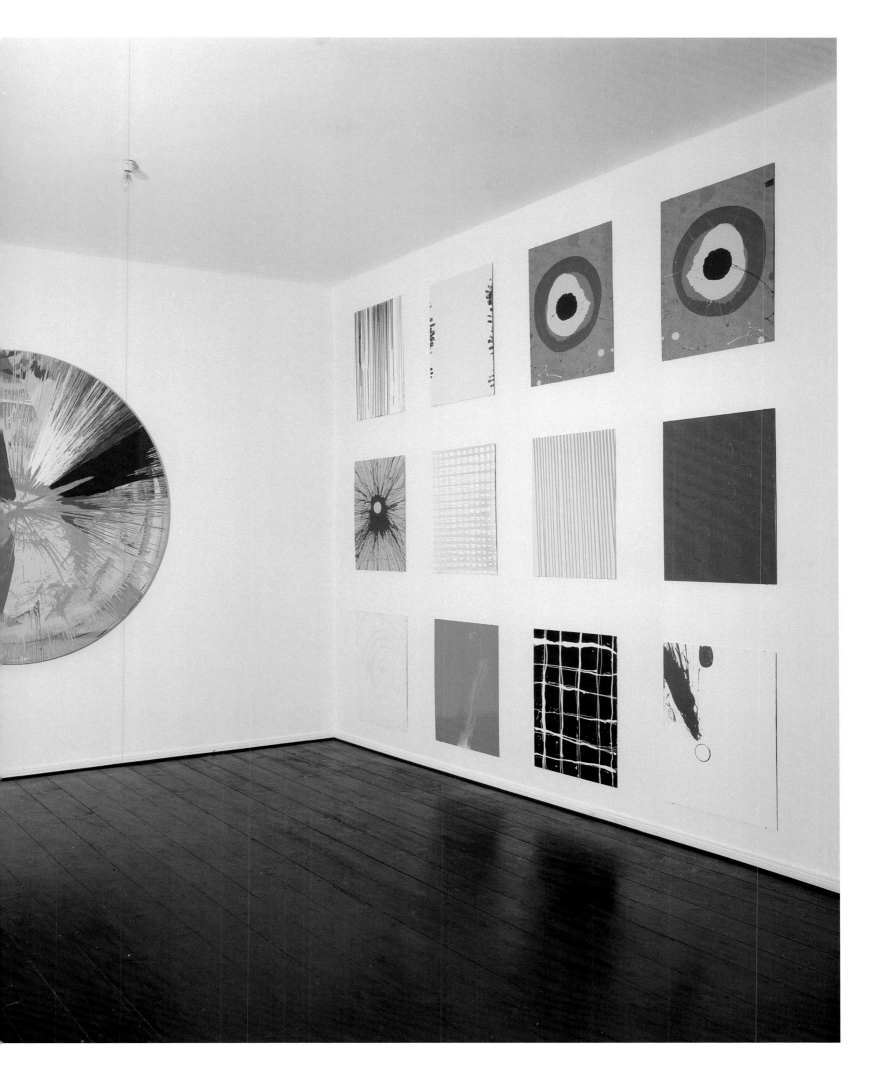

Stereo, 1995, Ausstellungsansicht I As exhibited **Top 10,** Gelbe Musik, Berlin

Hit Paraden, 1997

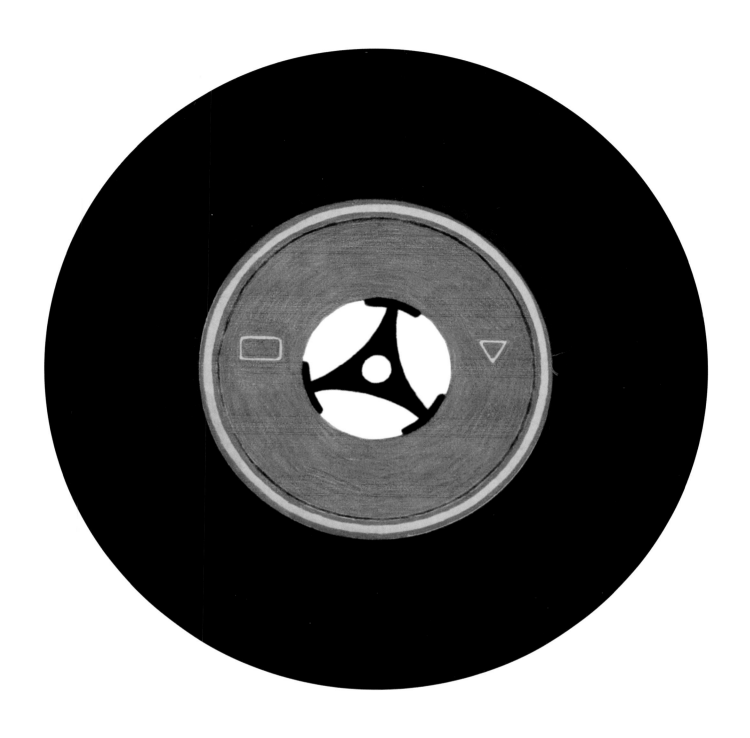

 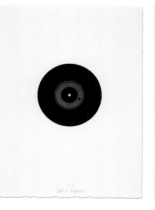 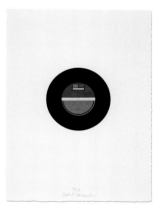 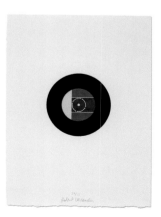

ROBERT LUCANDER – EINE ZWISCHENBILANZ. HARALD FALCKENBERG

»Aus finnischer Sicht bin ich kein Finne«, behauptet der 1962 in Helsinki geborene, seit langem in Berlin lebende Künstler Robert Lucander (im Gespräch mit Sven Drühl, *Kunstforum International,* Januar–März 2005). Seine Welt sei anders. Wirklich? Zunächst einmal ist Lucander ein Nordländer im besten Sinne, zurückhaltend, höflich auf Formen bedacht, fast schüchtern. Die Kleidung – Pullover, klassische Jacketts, dunkelfarbige Parkas und Baseball-Kappen mit Emblemen der Sport- und Modebranche – ohne jede Exzentrik und imagebildende Maßnahmen. Sein Gesichtsausdruck stoisch. Niemals drängt er sich auf. Trotz seiner Größe von über 1,90 m, seiner kräftigen Figur und dem markanten Gesicht mit reichlich kurz geschorenen Haaren, muss man ihn suchen. Ein Künstler – nach dem ersten Eindruck eher Eishockeyspieler oder Boxer. Im Gespräch zaubert Lucander ein Lächeln hervor, er spricht leise, fast liebevoll von seinen Vorhaben, immer offen – gern auch bereit, auf andere Themen und Personen einzugehen. Der sensible Riese. Wie es sich für unsere skandinavischen Nachbarn gehört, sind gute Gespräche begleitet von guten Getränken. Mit Vorliebe klare Sachen. Ist ein bestimmter Level erreicht, kann es zuweilen zu rabiaten Auftritten kommen. Es ist dann gut, an der richtigen Stelle zu sitzen und auf der richtigen Seite zu sein. Wir sind in solchen Situationen wieder angelangt im Land seiner Geburt, wo vieles so schwer und ernsthaft ist, wo sich Zärtlichkeit mit Grobheit mischt und wo Melancholie die höfliche Umschreibung tiefgreifender Depressionen und Identitätsfragen ist, angelangt in dem Land mit der weltweit höchsten Selbstmordrate.

Finnland im Schnittpunkt von Ost und West. Im 1. und 2. Jahrhundert besetzten die Ugrier, eine mongolische Rasse aus dem Ural, nach langer Wanderschaft das Land und verdrängten die Ureinwohner, die Lappen, in den hohen Norden. Wie die Ungarn – ebenfalls ugrischer Herkunft – haben die Finnen ihre Sitten, vor allem aber auch ihre Sprache bis heute gegen die indogermanischen Einflüsse Resteuropas verteidigen und bewahren können. Seit dem 9. Jahrhundert geriet *Suomi* – ugrisch für »Land der Seen und Sümpfe« – zunehmend unter den Druck der expandierenden Schweden und Russen. Die Schweden konnten sich zunächst durchsetzen und betrieben vom 12. bis zum 18. Jahrhundert eine massive Kolonisierung Finnlands. Noch heute sind rund fünf Prozent der Bevölkerung Schwedisch, über neunzig Prozent evangelisch-lutherisch, und Schwedisch ist neben dem Finnischen Amtssprache. Russland hielt in mehreren Kriegen dagegen und gewann schließlich die Oberhand, statt Turku im Westen machten sie im Jahr 1812 Helsinki zur Hauptstadt. Kurios genug, ein preußischer Offizier in russischen Diensten, Freiherr Carl Gustav von Mannerheim, sollte zum Nationalhelden Finnlands werden. 1867 auf einem finnischen Landgut geboren, trat er 1887 als Kavallerist in die Armee des Zaren ein. Nach der Oktoberrevolution 1917 schlug er sich auf die finnische Seite und bekämpfte in einem

ROBERT LUCANDER – AN INTERIM ASSESSMENT. HARALD FALCKENBERG

"From the Finnish point of view, I'm not a Finn," insisted long-term Berlin resident Robert Lucander, a native of Helsinki born in 1962, in an interview with Sven Drühl (*Kunstforum International,* January/March 2005). His world is different, Lucander says. Really? First of all, Lucander is a Northern European in the best sense of the term—meaning reserved, politely and prudently formal, almost shy. His clothing—sweaters, classic jackets, dark parkas, and baseball caps marked with sports or fashion emblems—is devoid of eccentricity or any image-making touches. His facial expression is stoic. He never imposes himself on anyone and despite his height of over six feet, a powerful figure, and memorable face with extremely short hair, he does not stand out in a crowd. An artist? At first glance he seems more like an ice hockey player or a boxer. In conversation, Lucander conjures up a smile; he speaks quietly—almost lovingly—about his plans, is always open and glad to discuss other subjects and people. A sensitive giant. As is customary with our Nordic neighbors, good conversations are invariably accompanied by a good drink. Preferably straight. And once a certain level has been reached, things can get rough at times. So it is good to be sitting in the right place and on the right side. It is in situations such as these that we return to the country of his birth, where so much is so difficult and serious, where the gentle and the tough go hand in hand, and where melancholy is the polite word for profound depression and identity crises—to the country with the highest suicide rate in the world.

Finland is at the junction of East and West. In the first and second century, it was invaded by the Ugrians, a Mongolian tribe from east of the Urals who upon reaching Finland after long years of wandering forced the indigenous population, the Lapps, into the high north. Like the Hungarians, whose ancestry is also Ugrian, the Finns have their own customs. Most important of all, they have succeeded in defending their language against the Indo-European influence of the rest of Europe, and have preserved it to this day. Starting in the ninth century, however, *Suomi* (Ugrian for "land of lakes and swamps") came increasingly under pressure from expanding Swedes and Russians. The Swedes were the first to conquer, and between the twelfth and eighteenth century went on to settle there in large numbers. Even now, around five percent of the population is Swedish, more than ninety percent Lutheran, and Swedish is the second official language after Finnish. After fighting several wars in an effort to reassert its claims, Russia finally won the upper hand. It was the Russians, therefore, who in 1812 made Helsinki the capital instead of Turku in the west. Curiously enough, Finland's national hero started out as a Prussian officer serving in the Russian army. Baron Carl Gustav von Mannerheim was born on a Finnish estate in 1867

blutigen Bürgerkrieg mit Unterstützung aus Deutschland die Bolschewiken, die schließlich die Unabhängigkeit Finnlands anerkennen mussten. Im Zweiten Weltkrieg führte er die finnischen Verbände mit großem Geschick gegen die übermächtigen russischen Truppen. Im September 1944 – inzwischen zum Staatspräsidenten gewählt – gelang es ihm, einen Waffenstillstand mit der Sowjetunion zu schließen und die Unabhängigkeit Finnlands zu bewahren. In Helsinki stehen seine Denkmäler, nicht zu wenige, Mannerheim hoch zu Ross mit erhobenem Säbel. Eigentümlich anmutende Zeugnisse einer verfahrenen europäischen Geschichte und deutsch-finnischen Sonderbeziehung.

Zurück zu Robert Lucander. In manchem erinnert er an den desertierten Rotarmisten Viktor in Detlev Bucks Roadmovie *Wir können auch anders* (1993). An einer Tankstelle überfällt Viktor die Brüder Rudi und Moritz in ihrem klapprigen Kleintransporter. Rudi und Moritz, Analphabeten und leicht beschränkt, irren in ihrem Fahrzeug durch Mecklenburg, um einen von der Großmutter geerbten Gutshof zu übernehmen. Das Problem: Die Brüder können keine Karten lesen. Viktor könnte helfen, doch er kennt nur kyrillische Schriftzeichen. Bei der Odyssee durch die Lande kommen sich die drei näher. Schließlich wird der Gutshof gefunden, eine fürchterliche Kaschemme. Noch bevor die notariellen Schritte in Angriff genommen werden, wird das Trio von einer Bande marodierender Straßenräuber überfallen. Gutes Zureden hilft nicht, wohl aber die Kalaschnikow von Viktor. Die Gangster flüchten sich überstürzt in ihren Wartburg, der an einem der idyllischen mecklenburgischen Seen abgestellt ist, und sitzen in der Falle. Seelenruhig schieben Viktor und die zwei Brüder den Wagen samt Inhalt in den See. Ihr lakonischer Kommentar: »Wir können auch anders.« Es kommt zu einer Großfahndung nach den drei Tätern, turbulenten Verfolgungsfahrten und vielem mehr. Irgendwie sind sie durchgekommen. Letzter Schnitt: eine idyllische russische Landschaft mit einem Dorf, freundlichen Menschen, Essen, Früchten und allem, was dazugehört. Viktor präsentiert seine Retter – verstehen können sie sich alle nicht. Bleibt anzumerken, dass Claus Boje, der Produzent des Films, einige Arbeiten von Lucander besitzt. Wohl kaum ein Zufall.

Der Anfangsverdacht hat sich nicht erhärtet. Nachfragen haben ergeben, dass Lucander definitiv nicht russischer Herkunft ist, er gehört zum anderen Besatzerstamm. Schwedisch, wie er betont, in der 9. Generation in Finnland, so seit Mitte des 17. Jahrhunderts. Aber doch offenbar nie ganz angekommen. Er sei in seiner Jugend wegen seiner Herkunft oft attackiert und verspottet worden. Kein Russe, nicht eigentlich Finne und nicht mehr Schwede, ab 1989, der Zeit der Wende, in Berlin an der Hochschule der

and joined the Czarist army as a cavalryman in 1887. After the revolution of October 1917, he went over to the Finnish side and with help from Germany fought a bloody civil war against the Bolsheviks, who in the end were forced to acknowledge Finland's independence. During the Second World War, Mannerheim led the Finnish forces with great skill against the almost overwhelming might of the Russians. In September 1944, having in the meantime been elected president of the country, he managed to sign a peace treaty with the Soviet Union and so uphold Finland's independence. There are more than a few monuments to him in Helsinki, that of Mannerheim on his steed with saber drawn being a strangely impressive witness to the muddle of European history and the special relationship between Germany and Finland.

Back to Robert Lucander. In some ways, he recalls Viktor, the Red Army deserter in Detlev Buck's 1993 road movie, *Wir können auch anders* (We can do things differently). At a gas station, Viktor attempts to rob two brothers who are traveling around in a rickety little van. Both illiterate and of somewhat limited abilities, Rudi and Moritz are driving aimlessly through Mecklenburg in search of their grandmother's estate, which they have inherited. The problem is that neither of them can read a map. Viktor might be able to help, but can read only Cyrillic script. During their odyssey through the countryside, the three get to know each other. When the estate is finally found, it turns out to be a terrible dive. Before the brothers can have their papers notarized, however, the trio is attacked by a marauding band of highway robbers. Friendly persuasion does no good, but Viktor's kalashnikov comes in handy. The gangsters flee in disarray to the East German getaway car they have parked on the shore of one of Mecklenburg's idyllic lakes—only to discover that they are trapped. As Viktor and the two brothers calmly push the car and its contents into the lake, one of them casually remarks "We can do things differently." Of course, the police are soon after them and there are turbulent car chases and much more besides. Somehow, the three manage to survive it all unscathed and the last scene shows an idyllic Russian landscape with a village, friendly people, food, fruit, and everything else that goes with it and Viktor presenting his rescuers—who of course cannot understand anything. All that remains to say is that Claus Boje, the film's producer, owns some of Lucander's works; that can hardly be a coincidence.

The original suspicion does not pan out. After some inquiries, it turns out that Lucander is definitely not of Russian origin; his ancestors belonged to the other conquering tribe. His family is Swedish, but has been in Finland for nine generations, he is keen to stress,

Künste. Lucander verschließt sich der Geschichte nicht und macht sich daran, sie künstlerisch aufzuarbeiten. Nicht intellektuell und diskursiv. Er sammelt. Die Hinwendung und das Suchen nach Objekten und Objektivem sind eine klassische psychologische Reaktion auf Entbehrungen und Verletzungen, eine Art magischer Fluchtweg in eine eigene Welt zur Kompensation von Unsicherheit und Verlustängsten.

An der Hochschule in Berlin findet Lucander sein Grundmaterial. Es ist das Holz der Transportkisten für Kunstwerke. Bräunlich im Grundton, mit den unterschiedlichen, über lange Zeit gewachsenen Maserungen und robust, bestens auch für rabiate Bearbeitungen geeignet. Holz, das ist ein fürwahr skandinavischer Stoff – mit einer kleinen ironischen Fußnote: Das Holz der Transportkisten stammt aus den Tropen. Lucander stört das nicht. Neben Holz in allen Varianten trägt er Zeitschriften, Magazine, Schallplatten, Filme, Videos aus aller Welt – mediale Produkte und Bilder, mit Vorliebe Cover – zusammen. Als Farben verwendet er Industrielacke aus dem Osten, die sich durch ihren dumpfen Grundton von den auf Glanz gebrachten westlichen Produkten unterscheiden.

In der ersten Werkphase überzieht er die Holzplatten mit geometrischen, linearen und monochromen Kompositionen, in der Tradition von Kasimir Malewitsch bis Blinky Palermo, Suprematismus als Verdrängung des Persönlichen und Hinweis auf eine höhere Ordnung. Ab 1996 geht es um mediale Produkte und Bilder, um lachende Partymenschen, die scherenschnitthaft mit ihren Gebärden, ihrer Mimik und Gestik auf das Holz appliziert werden, lachend, aber doch hohl und lächerlich. Später dann Porträts von Außenseitern – Obdachlosen, Wodkaverkäuferinnen und Alten. Die im Verlauf seiner Arbeit zunehmend düster gewählte Farbskala entlehnt Robert Lucander Magazinen der Heavy-Metal-Szene. Was auch aufgebracht wird, das Holz mit seinen den Bildern unterlegten Maserungen bleibt dominant. Das Neue, Gegenwärtige und Alltägliche – letztlich nur flüchtige Varianten auf gewachsenen Strukturen: *Semper eadem sed aliter,* die Welt bietet immer dasselbe Schauspiel, eine Mischung aus Komödie und Tragödie, nur jeweils in anderem Kostüm.

Als Referenz werden häufig die Arbeiten von Alex Katz und Elizabeth Peyton herangezogen. Richtig ist, dass es hier wie dort um die Unfähigkeit von Menschen zu einem eigenen Leben und ihr Unvermögen zur Selbstbestimmung geht. Bei Katz und Peyton sind

meaning since the mid-seventeenth century. Yet it seems they never really arrived. During his youth, apparently, Lucander was often attacked and teased because of his ancestry. Neither Russian, nor really Finnish, and no longer Swedish, in 1989—around the time the Berlin Wall fell—he enrolled at the Hochschule der Künste in Berlin. Rather than closing his eyes to history, Lucander began studying it through his art. Non-intellectually and non-discursively. He collects. The attraction to and search for objects and the objective is a classical psychological reaction to deprivation and injury—a kind of magical escape route into his own world, compensation for insecurity and the fear of loss.

It was at the academy in Berlin that Lucander found his material. This is the wood used to make crates for transporting works of art. Robust and basically brown in hue with a grain that has taken years to develop, it is ideal for rough work. Wood—a quintessentially Nordic material, but with an ironic footnote, for the wood used for these crates comes from the Tropics. Not that this matters to Lucander. Besides all kinds of wood, he also collects magazines, records, movies, videos from all over the world—media products and images and covers whenever possible. The paint he uses is industrial enamel paint from the East, which seems dull in comparison to the brightly colored paints produced in the West.

In the first phase of his work, Lucander covers his wooden boards with geometrical, linear, monochromatic compositions, following a tradition reaching from Kasimir Malevich to Blinky Palermo—Suprematism as the repression of the personal and a reference to a higher order. Starting in 1996, he began working on media products and images of laughing party-goers, whose gesticulating, facial expressions, and gestures were applied to the wood in a process similar to that used in making silhouettes. The figures laughed, but were somehow still hollow and ridiculous. Later, Lucander produced portraits of outcasts—the homeless, women selling vodka, and the elderly, the increasingly gloomy colors of his works inspired by heavy metal magazines. Regardless of what is put on it, the wood with its grain underneath the images always remains dominant. The new, the contemporary, and the ordinary—ultimately only fleeting variants of mature structures: *Semper eadem sed aliter*—always the same old show, the same mixture of comedy and tragedy in which only the costumes change.

die Personen aber als solche dargestellt und stehen im Zentrum der Arbeiten. Die Menschen in der Sicht Lucanders sind fragmentiert und flattern wie Vögel über die Bildfläche. Das Persönliche und Emotionale sind vollständig verdrängt. In diesem Ansatz trifft sich Lucander mit Neo Rauch und dessen schablonenhaft-seelenloser Darstellung. Auffällig ist auch, dass beide Künstler die dumpfen Ostfarben als Grundton der Stimmung verwenden. In beiden Fällen wird das monotone Treiben von Menschen geschildert, die aufgrund der historischen und politischen Umstände nicht zu eigener Identität finden können.

Lange hat sich Lucander an diesen Sujets abgearbeitet. Die Frage nach dem Inhalt, von Sven Drühl gestellt, scheint ihn zu überraschen. Ihn interessiere, wie man einen Konflikt schön male, dass Tod nichts mit Ekeligem zu tun habe und die kritische Abbildung der Vororts-Idylle-Schick-Realo-Helden. Nein, politisch denke er nicht. Leiden wird als ontologische Tatsache akzeptiert und künstlerisch überhöht in dekorative Motive umgesetzt. Mit dieser Haltung reiht sich Lucander in die unpolitische und ahistorische, von Melancholie geprägte skandinavische Kunstrichtung ein, die Per Kirkeby als »nordischen Manierismus« bezeichnet.

Nordischer Manierismus, das ist in der Tat ein Fixpunkt in der Arbeit Robert Lucanders. Aber er entwickelt sich weiter. Ab 2003 beginnt er seine Arbeiten über den Fußboden zu schleifen, sie zu verletzen, zu den fiesen Farben des Ostens kommen jetzt kaputte Oberflächen, das alte Holz hält die plastische Bearbeitung aus. Lucander sieht das ganz locker. Die Zerstörungen entsprächen dem anonymen Vandalismus in den Straßen und würden die Arbeit realer erscheinen lassen. Kein Hinweis auf Asger Jorns Nordisches *Institut für vergleichenden Vandalismus* aus Zeiten des Situationismus, fast fünfzig Jahre zurück. Lucander, der finnische Mr. Cool, kennt diese Zusammenhänge natürlich, will sich auf sie offenbar aber nicht einlassen. Er setzt auf sein Metier des Malens, Zeichnens und Gestaltens. Honoré de Balzac, wie Lucander zeitlebens ein leidenschaftlicher Sammler, meinte im Rückblick resignierend: »Am Ende glaube ich, dass ich nur ein Instrument bin, auf dem die Umstände spielen.« Dieses Resümee scheint auf Robert Lucander zugeschnitten – als Zwischenbilanz. Ende offen.

The works of Alex Katz and Elizabeth Peyton are often mentioned in this connection. It is true that all three artists show how incapable people are of leading their own lives, of choosing their own paths. Katz and Peyton portray people for what they are and make them the focal point of their works. Lucander's people, on the other hand, are fragmented and flutter like birds over the surface of the image. The personal and the emotional are completely repressed. This approach resembles that of Neo Rauch and his silhouette-like, soulless representations. Also noticeable is the fact that both artists use dull Eastern European colors to convey the underlying mood. Both artists' portraits depict the monotonous activity of people who because of their historical and political circumstances cannot find their own identity.

Lucander has worked for a long time on these subjects. Sven Drühl's question about the content of his work seems to surprise him. What interests him, he says, is how to paint a conflict beautifully, the fact that there is nothing disgusting about death, and critical portrayals of the smartly clad realist heroes thrown up by the suburban idyll. No, he is not a political thinker, he says. Suffering is accepted as an ontological fact and then transformed into decorative, artistically amplified motifs. With this attitude, Lucander joins the ranks of Scandinavia's non-political, ahistorical and fundamentally melancholy art movements—such movements as Per Kirkeby describes as "Nordic Mannerism."

Nordic Mannerism is indeed a fixed point in Lucander's oeuvre. Yet he has developed further. In 2003, he began dragging his works across the floor, began deliberately hurting them, adding a damaged surface to their Eastern European drabness. The old wood holds its own against the sculptural treatment to which it is subjected and Lucander himself is unperturbed. The destruction, he says, merely matches the anonymous vandalism of the streets and so makes the works seem more real. No mention of Asger Jorn's *Nordic Institute for Comparative Vandalism* from the days of Situationism now almost fifty years ago. Lucander, the Finnish Mr. Cool, is familiar with these associations, of course, but obviously not willing to explore them. He relies on his métier of painting, drawing, creating. Reflecting resignedly on his life, Honoré de Balzac, who like Lucander, was a passionate collector throughout his life, once remarked that "ultimately, I believe I am just an instrument upon which circumstances play." This summary appears to fit Robert Lucander perfectly—at least as an interim assessment. The end remains to be seen.

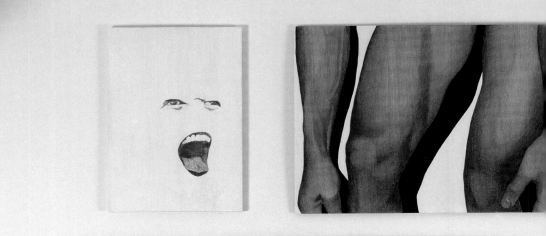

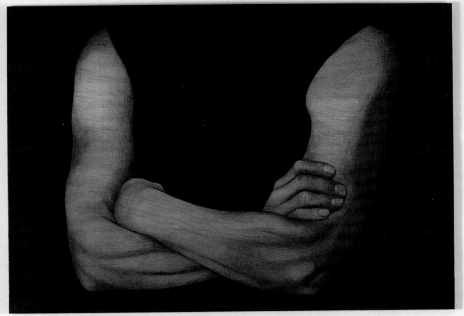

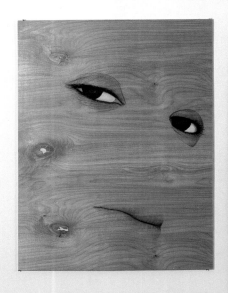

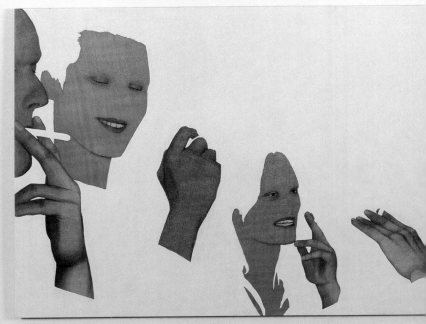

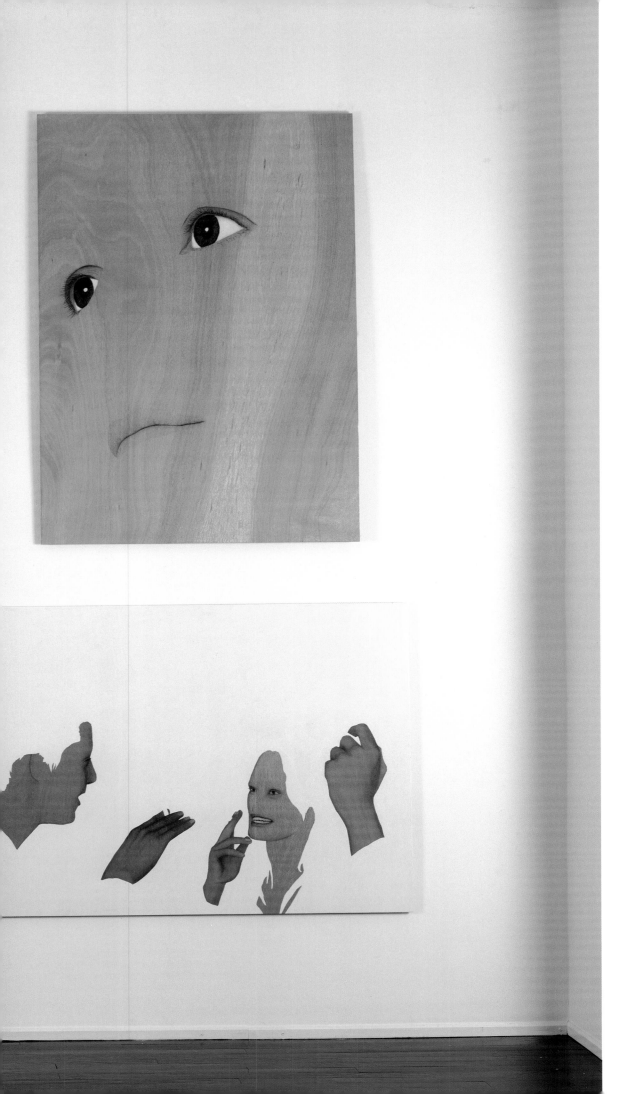

Installationsansicht I Photo of installation Contemporary Fine Arts, Berlin 2000, mit folgenden Werken (v. l. n. r.) I with the following works (l to r):
Ohne Titel, 2000; **Essence of freedom**, 1999; **Man muss Gutes in Frage stellen, um Perfektes zu schaffen**, 1999;
Nur die Wirklichkeit wirkt wirklicher, 1999; **Full head mask**, 2000; **Die Stimmungsbombe**, 2000

33

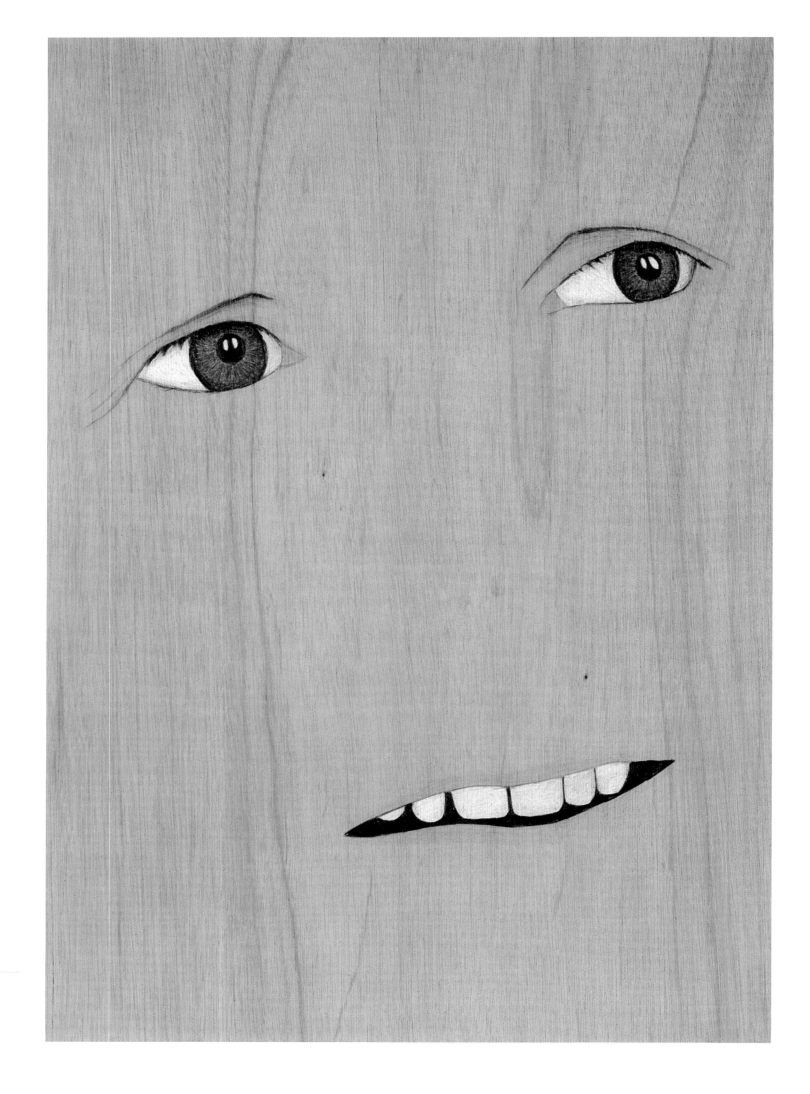

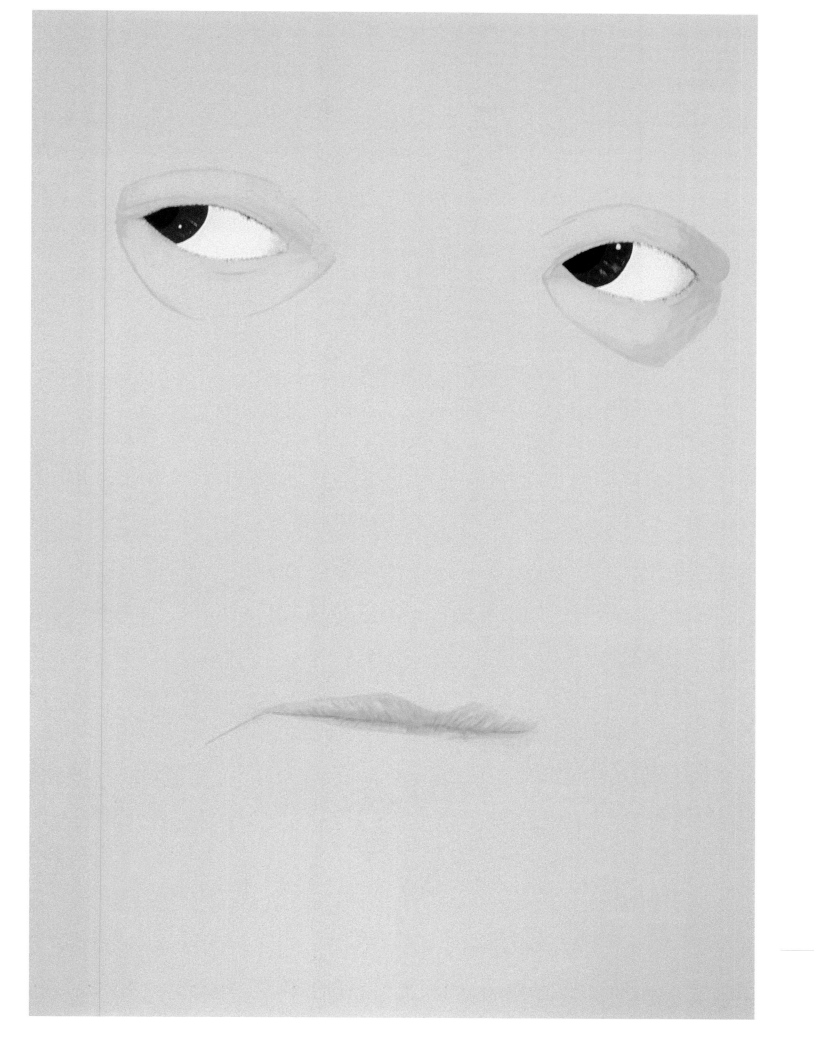

B. K., 1995

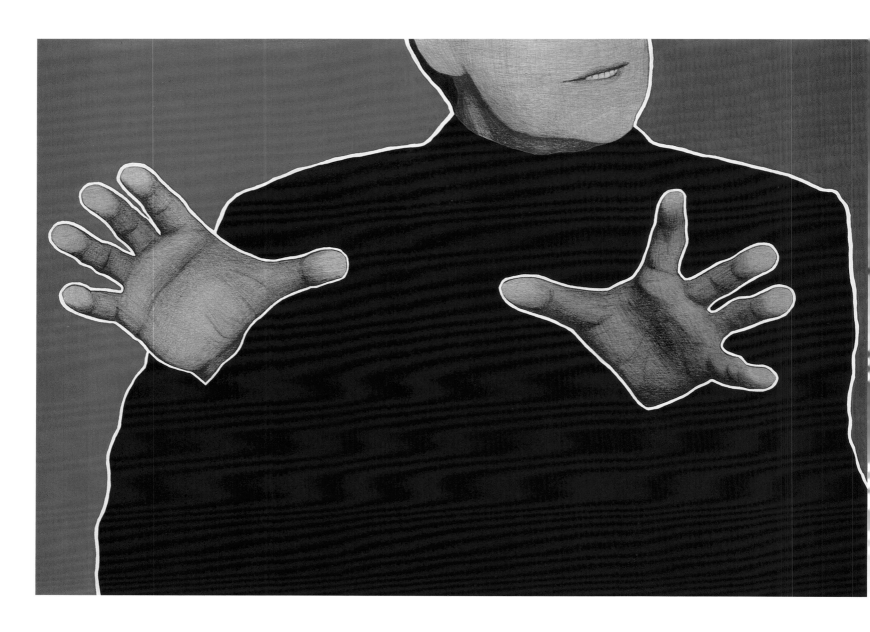

Der Kombi Pack, 2000

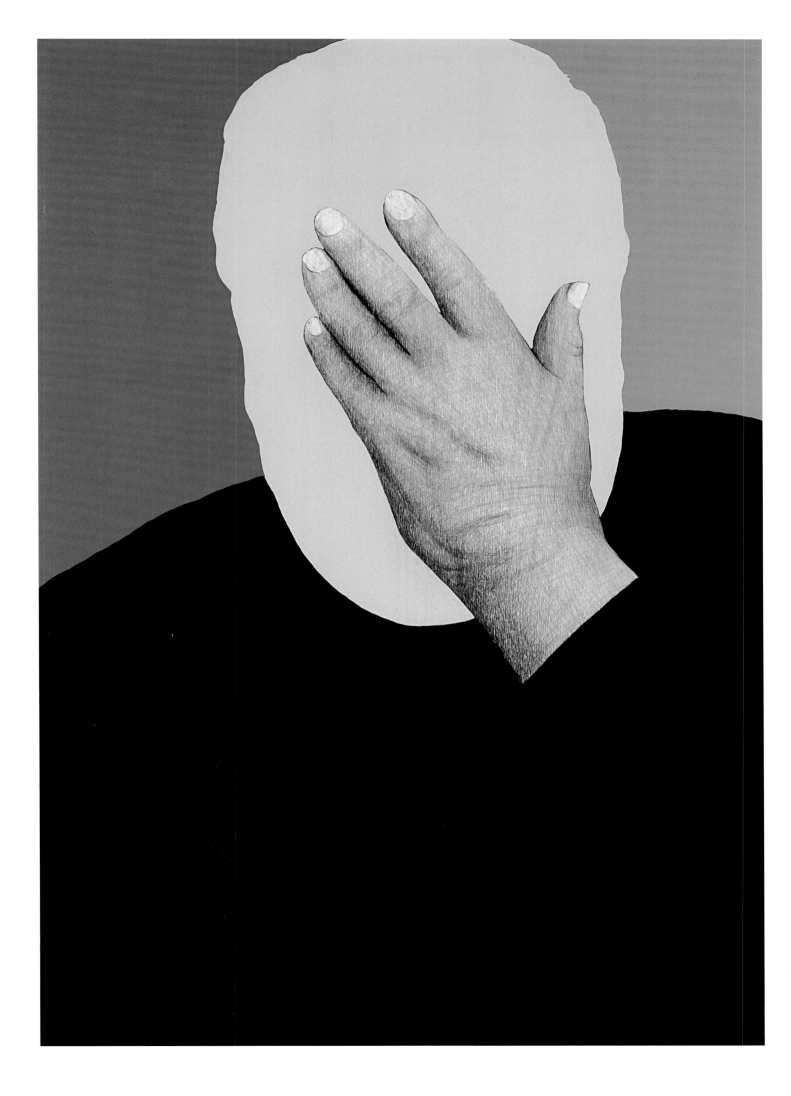

Der Mann leidet wirklich, sagt einer, der ihn kennt, 2000

Accatone, 2000

Aber ich habe das immer schon gewußt von der, weil die
nicht gerade schaut, immer so vorbei 2000

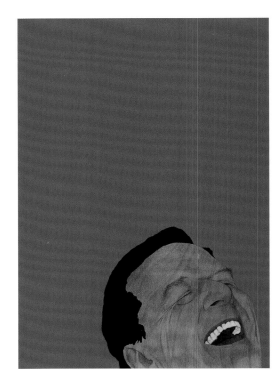

Weil mein Job es erfordert, 2001
Zum Tanzen und Mitjubeln, 2001
Schluss mit langweilig, 2001

44

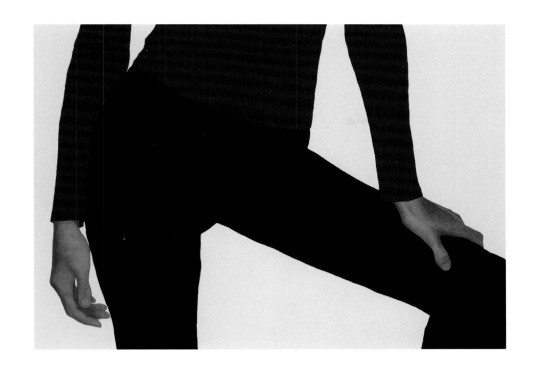

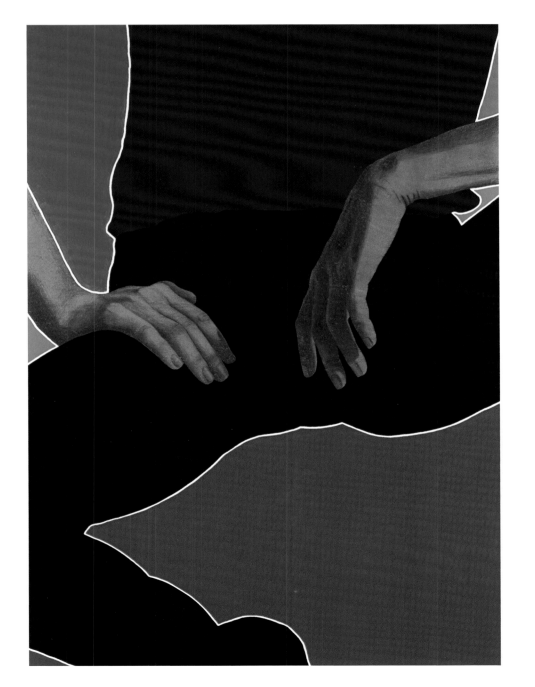

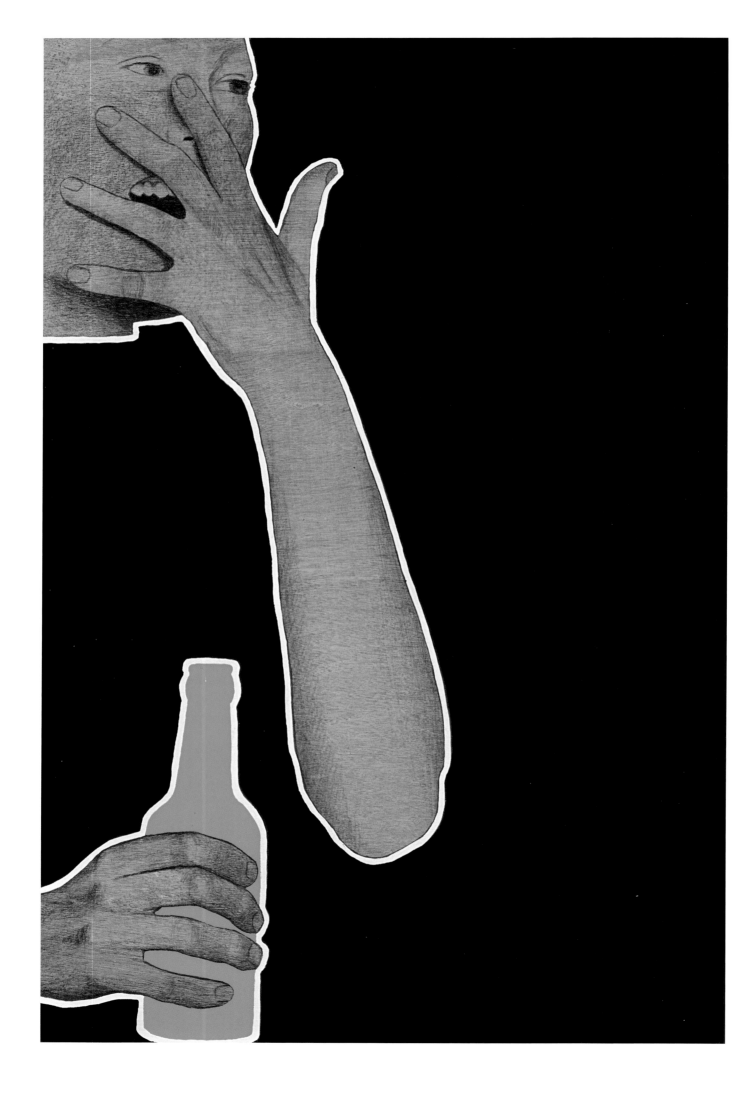

No. 103/E, 2000

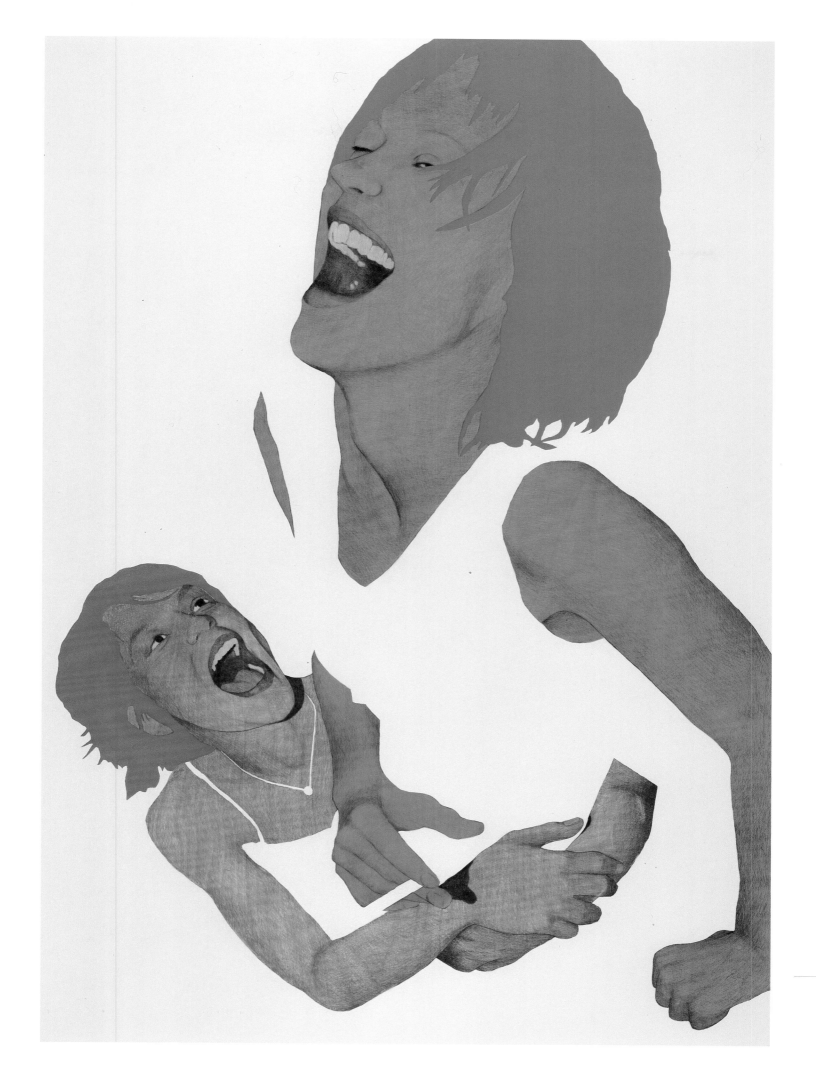

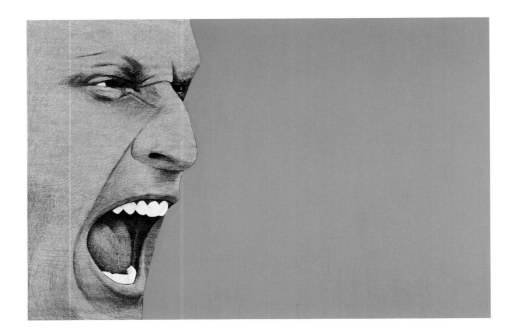

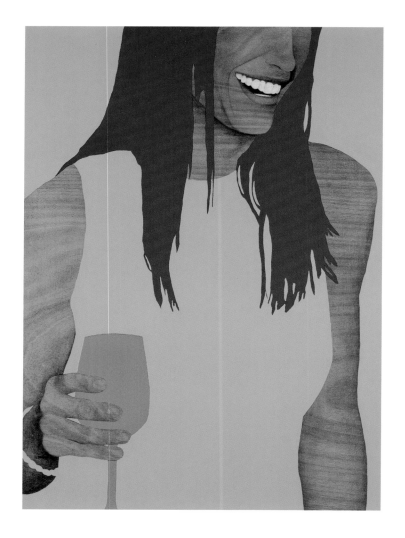

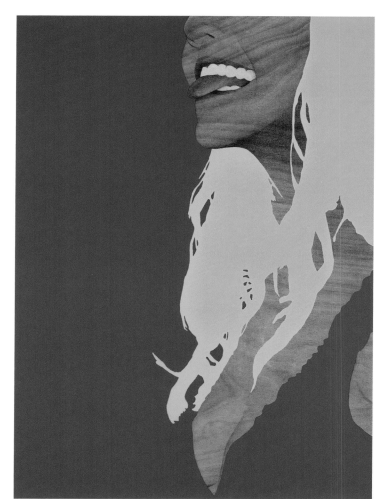

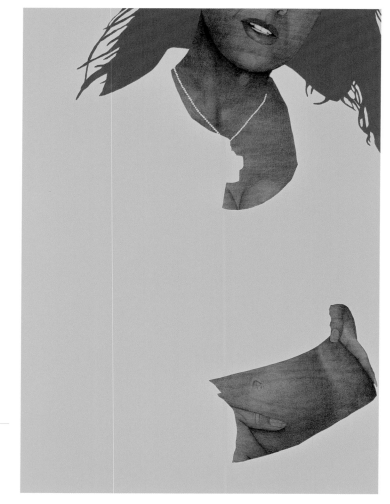

Die Gefahr wurde stark unterschätzt, 2001
Ich mache alles! Ich wasche ab, staubsauge, putze und mache die Betten, 2001
Es war nicht so, dass ich mich verändert hätte, 2001

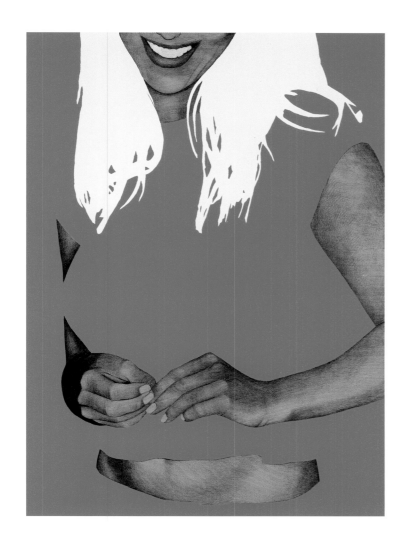
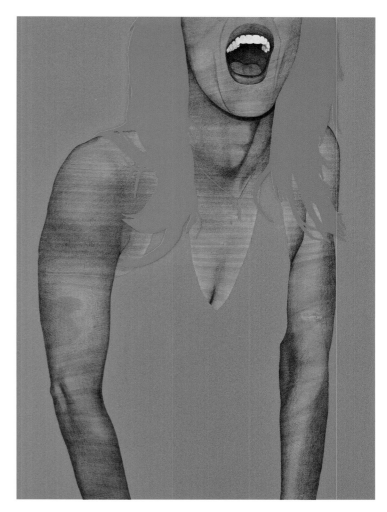

Ich dachte, das sei der beste Weg, Freunde zu werden, wir hätten beide einen Oscar gewinnen können, 2001
Strategische Mehrdeutigkeiten, 2001

Ausstellungsansicht I As exhibited **Party with Attitude** im I at Turun taidemuseo, Turku (09.03.–22.04.2001)

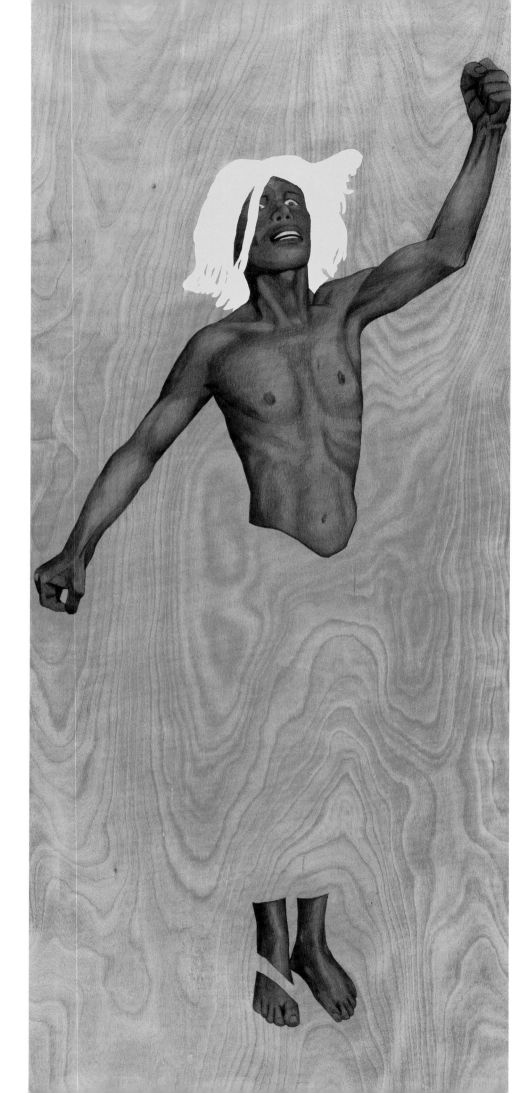

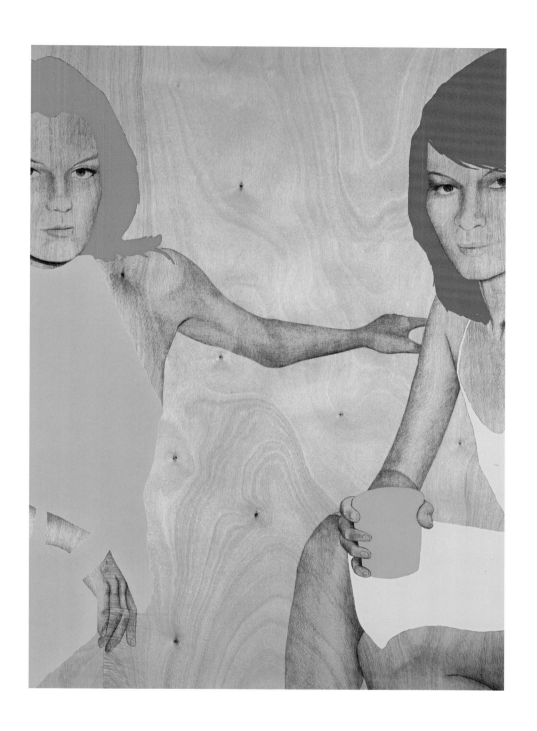

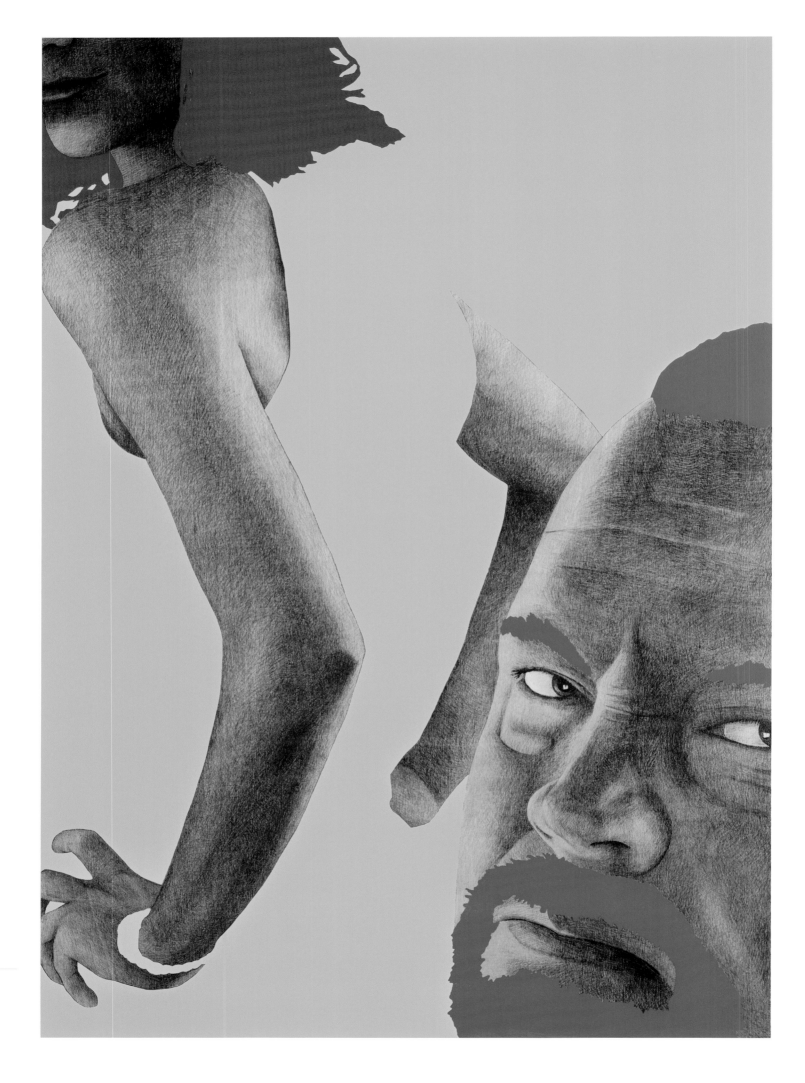

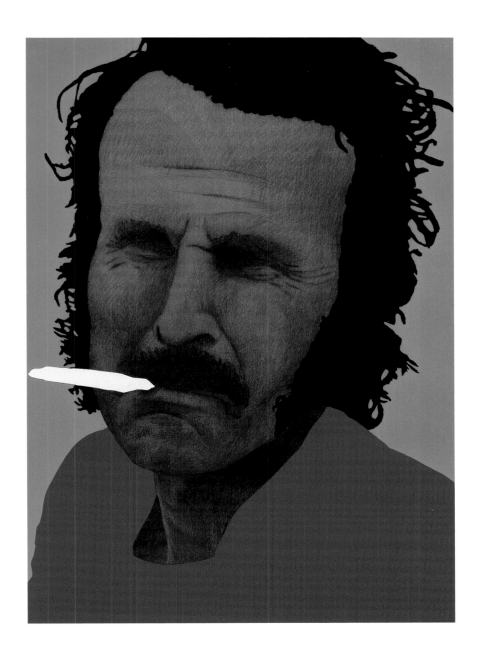

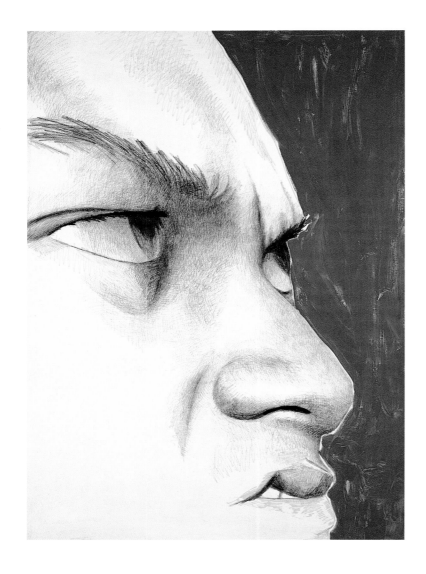
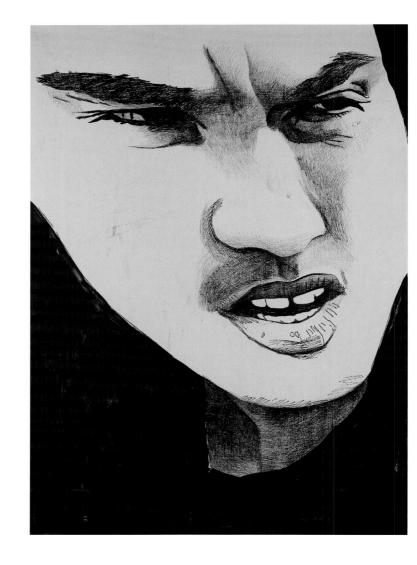

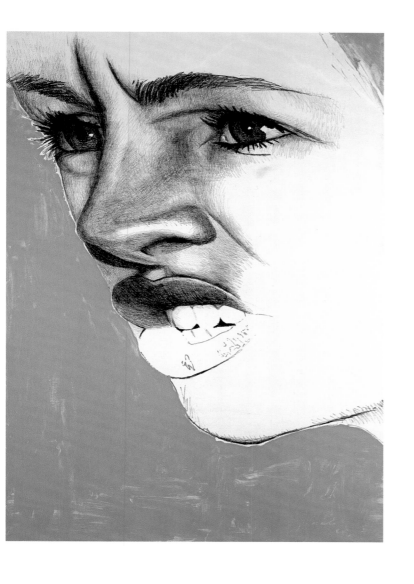

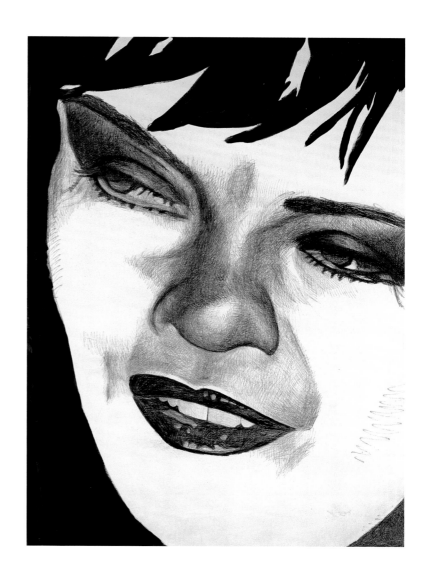

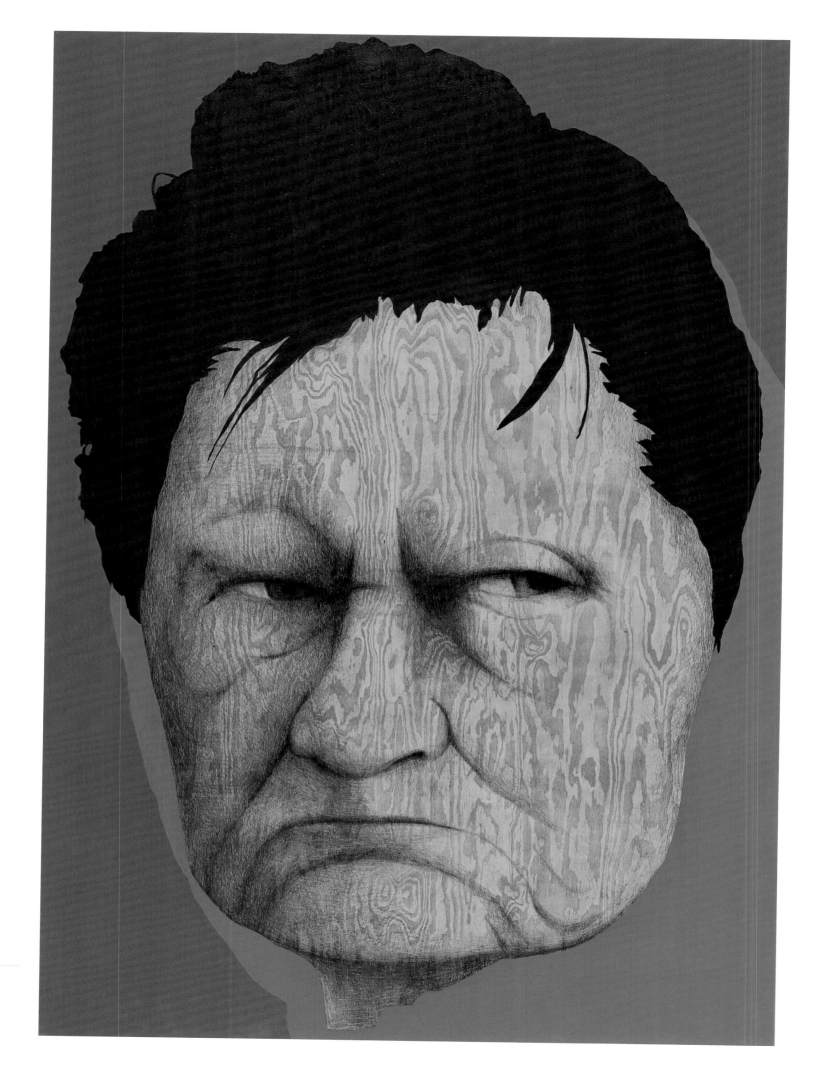

Ausdruck einer wundersamen Freundschaft, 2003

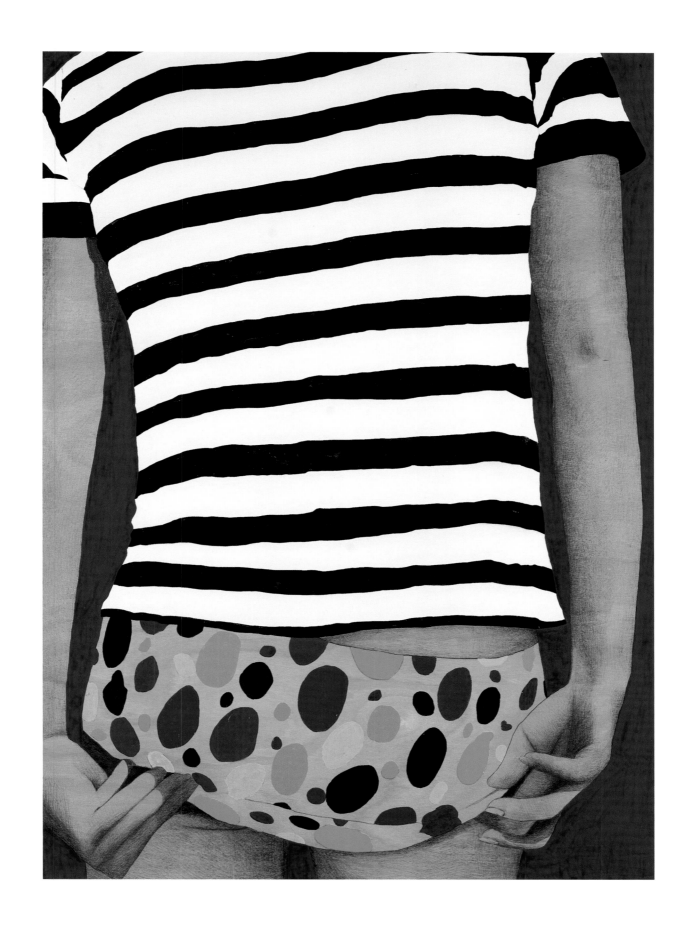

Gefährlich klug und angriffslustig, 2003

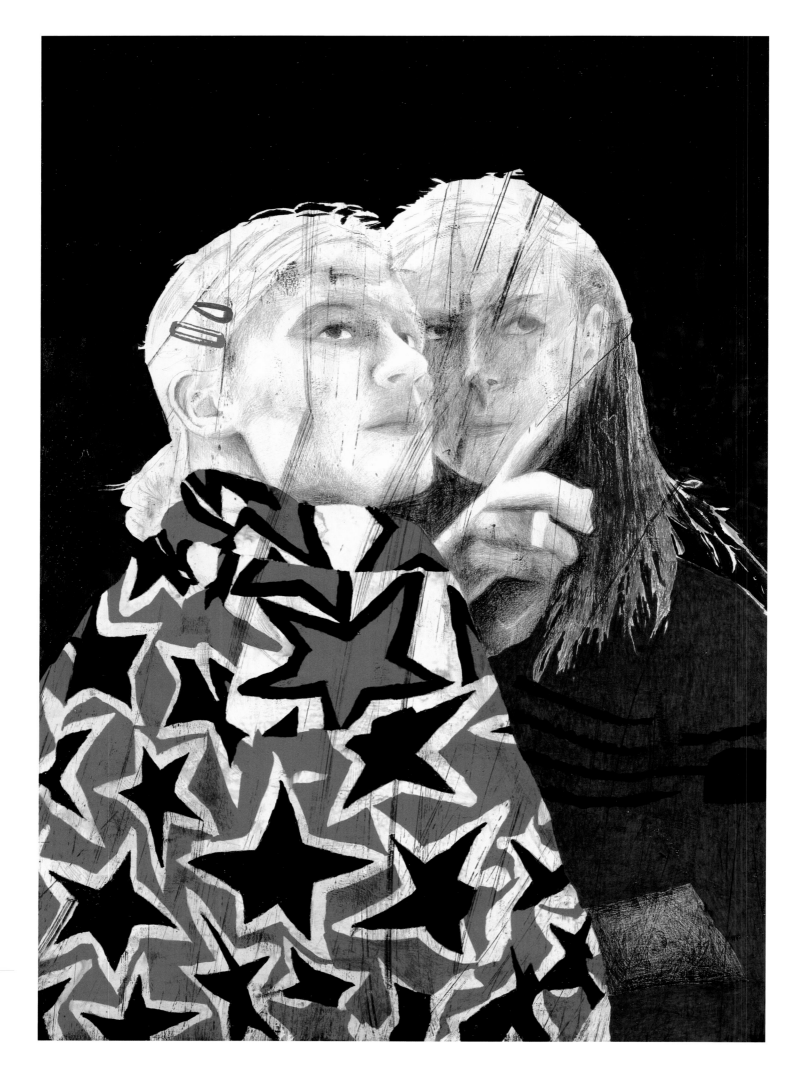

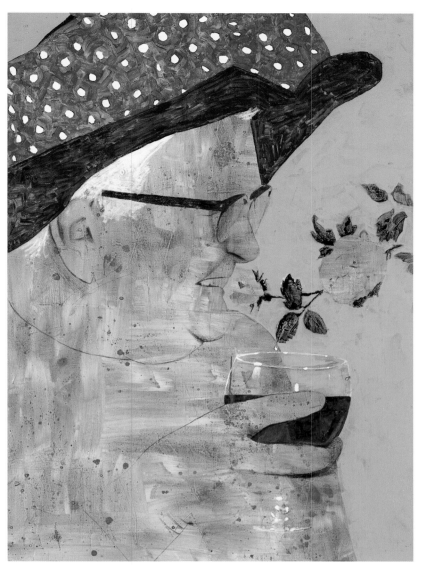
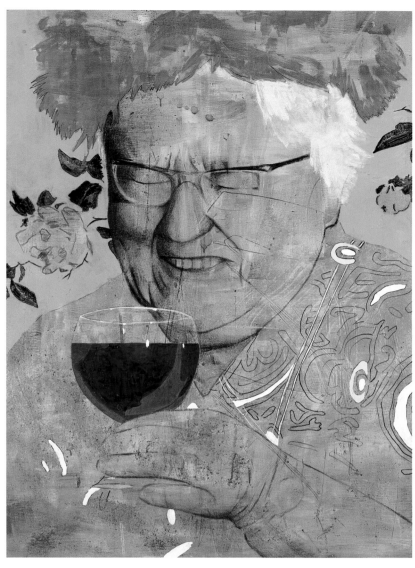

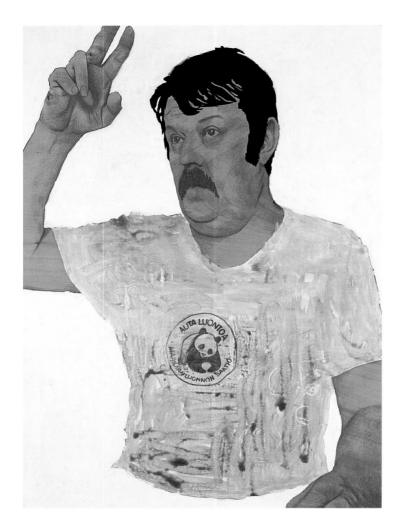

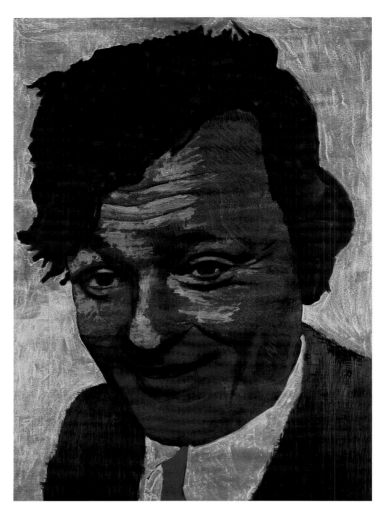

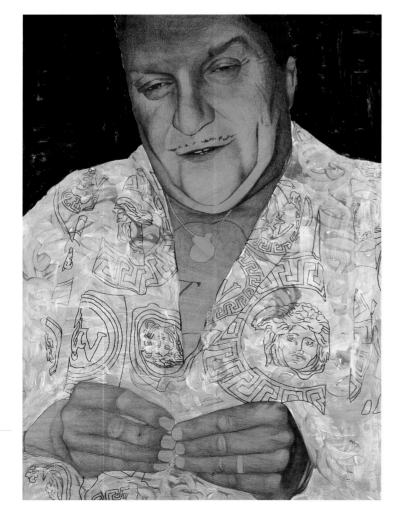

Da weiß man, was man hat, 2002
... macht mehr sichtbar, als es zu sehen gibt, 2002
Eine andere Liga, 2002

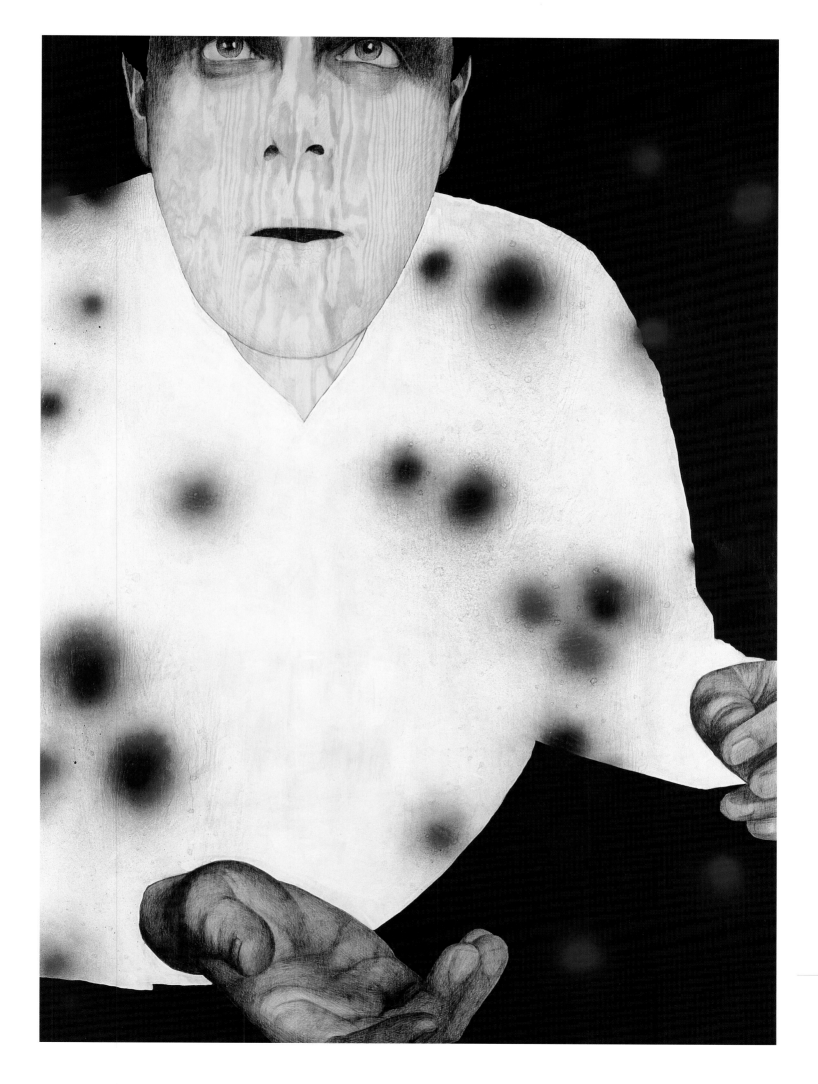

Ich weiß nicht, wie die Dinge sich jetzt weiterentwickeln, 2003

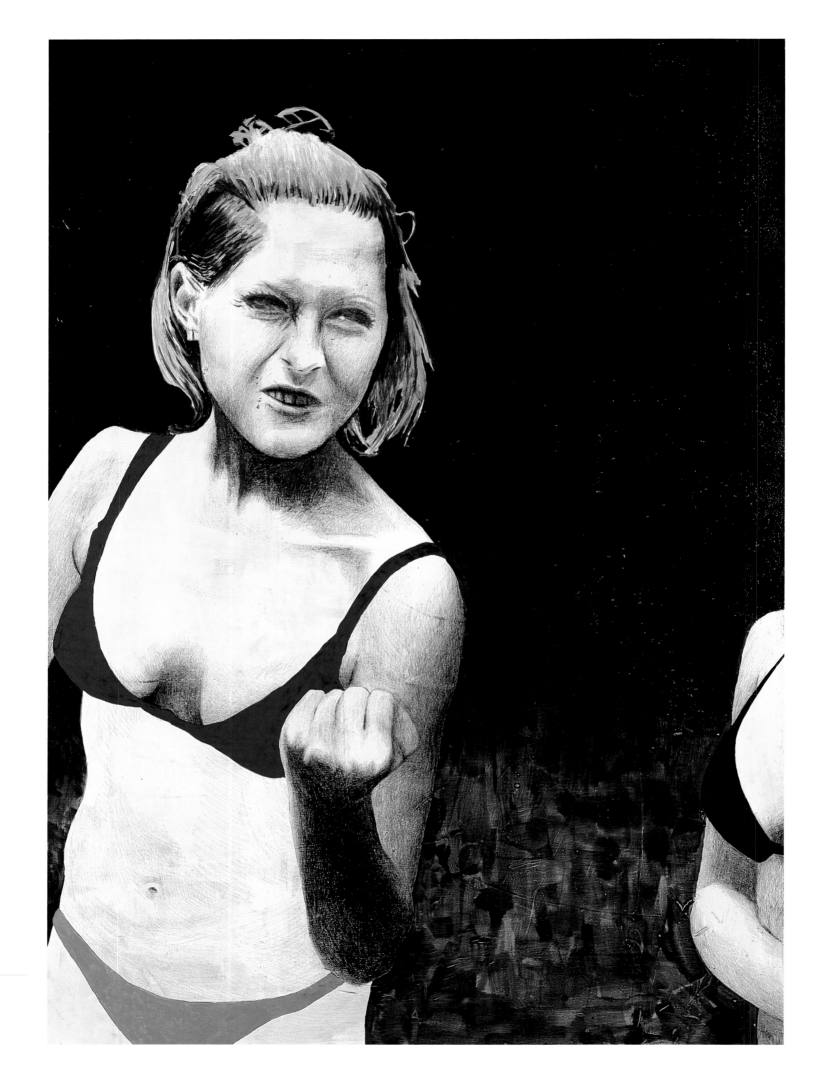

Klartext, 2003

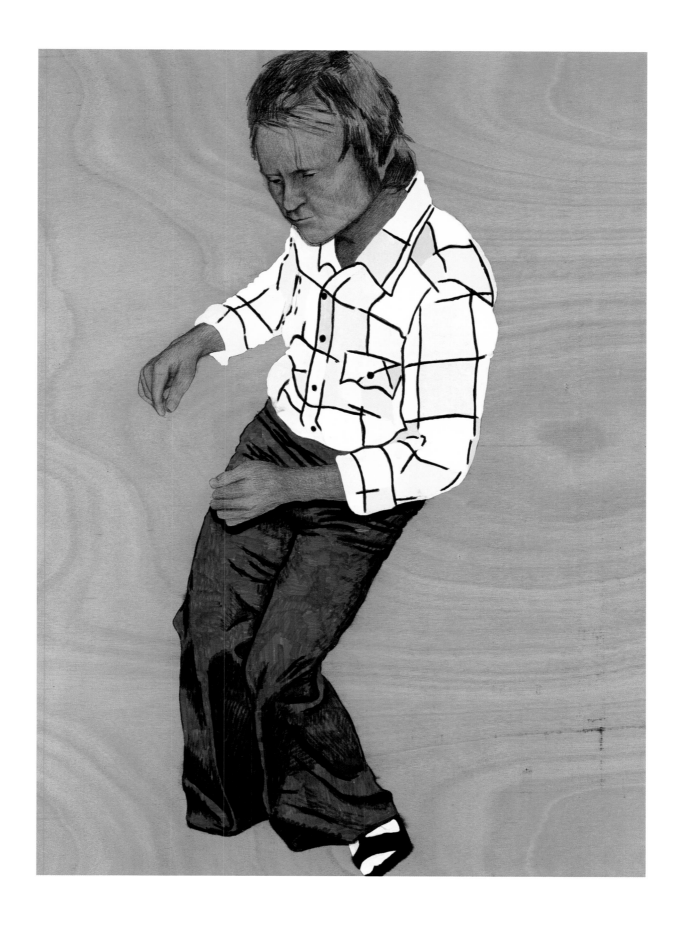

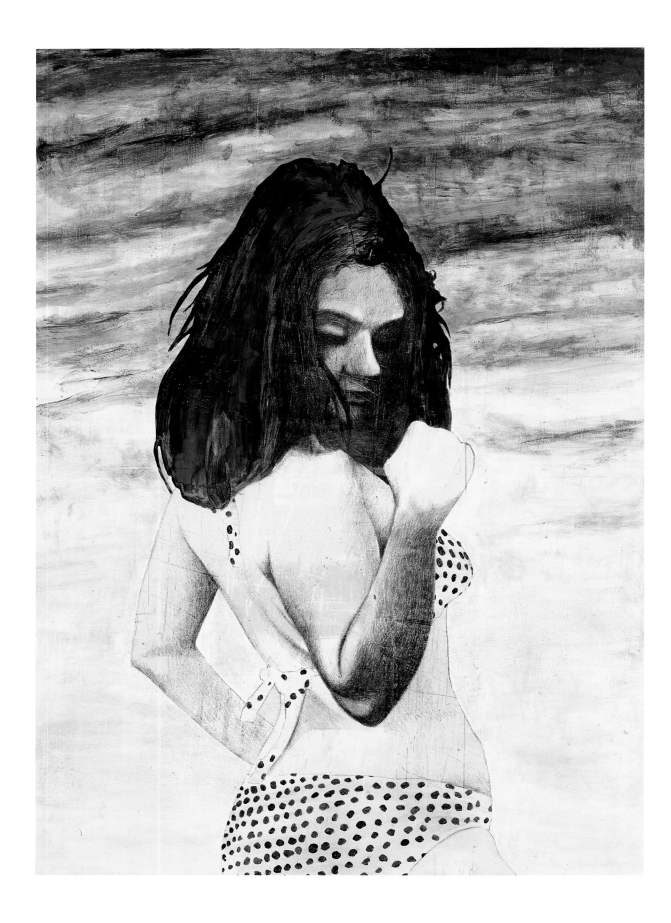

Jetzt ist Schluss mit muffig, 2003

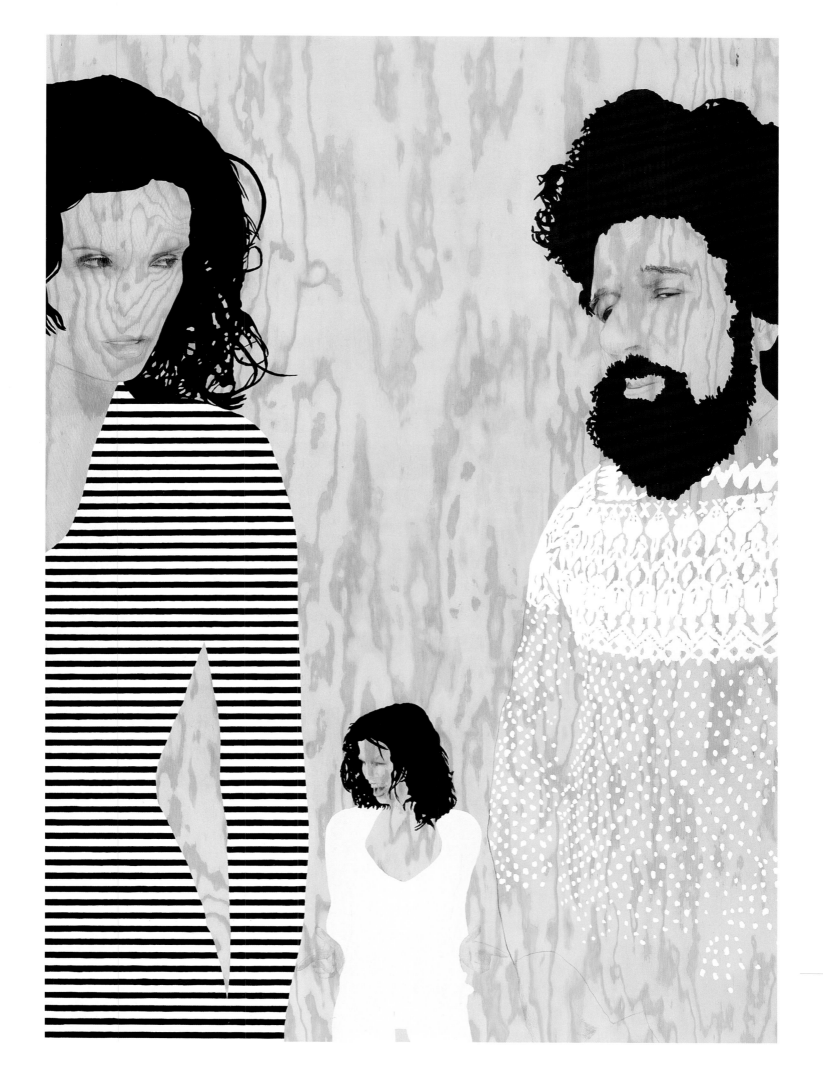

Kann man das essen?, 2003

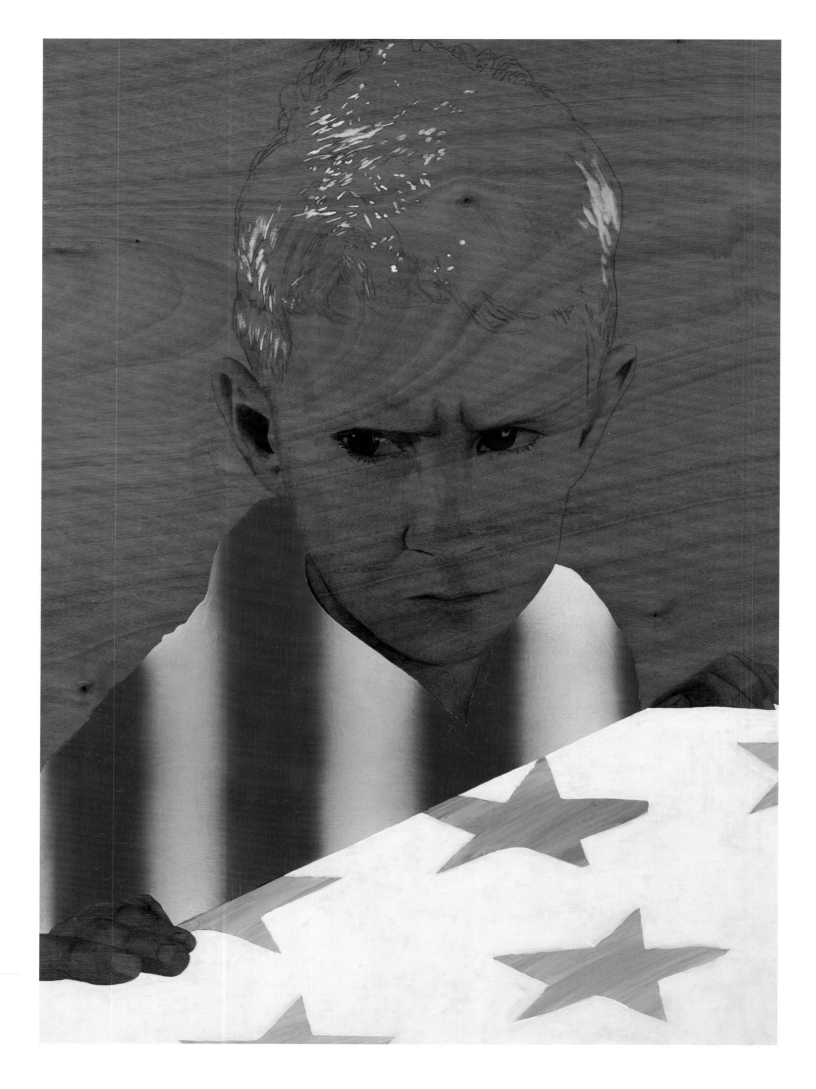

Erfinden sie ein Problem, 2005

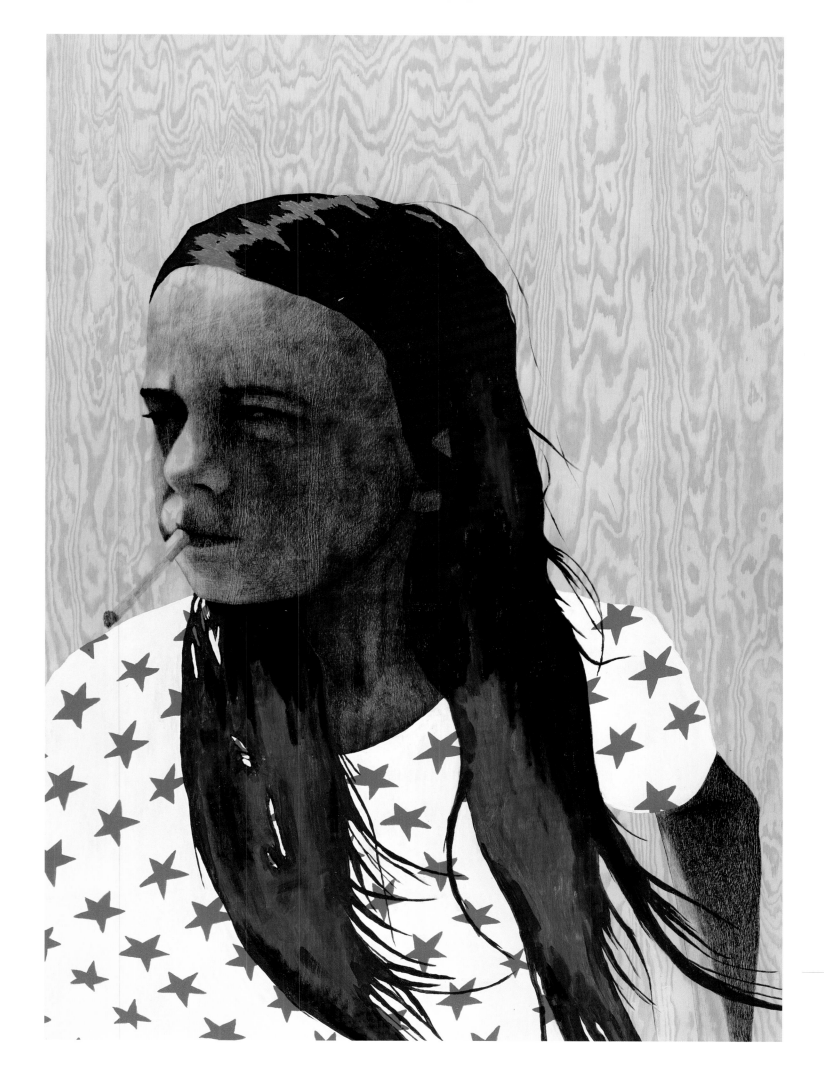

Das war sehr respektvoll, sie hätten das nicht tun brauchen, doch sie taten es, sie wissen, dass ich sie liebe, 2003

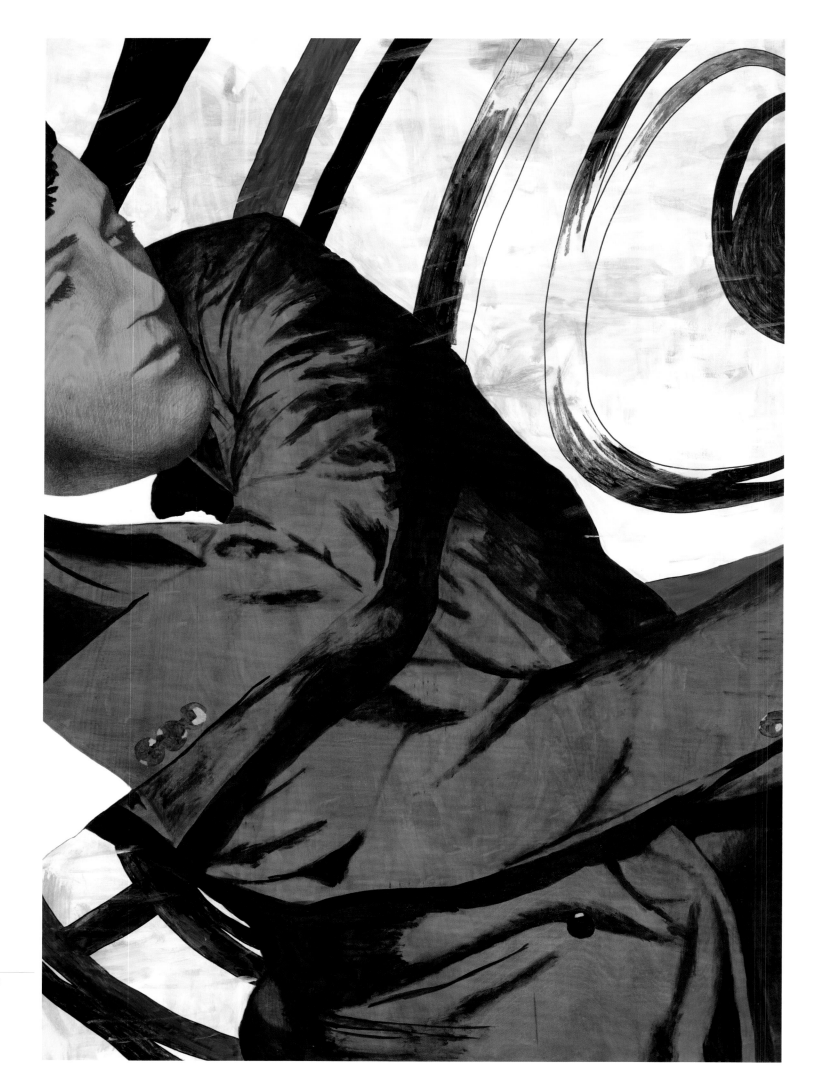

Ich könnte mich ohrfeigen (links), 2004

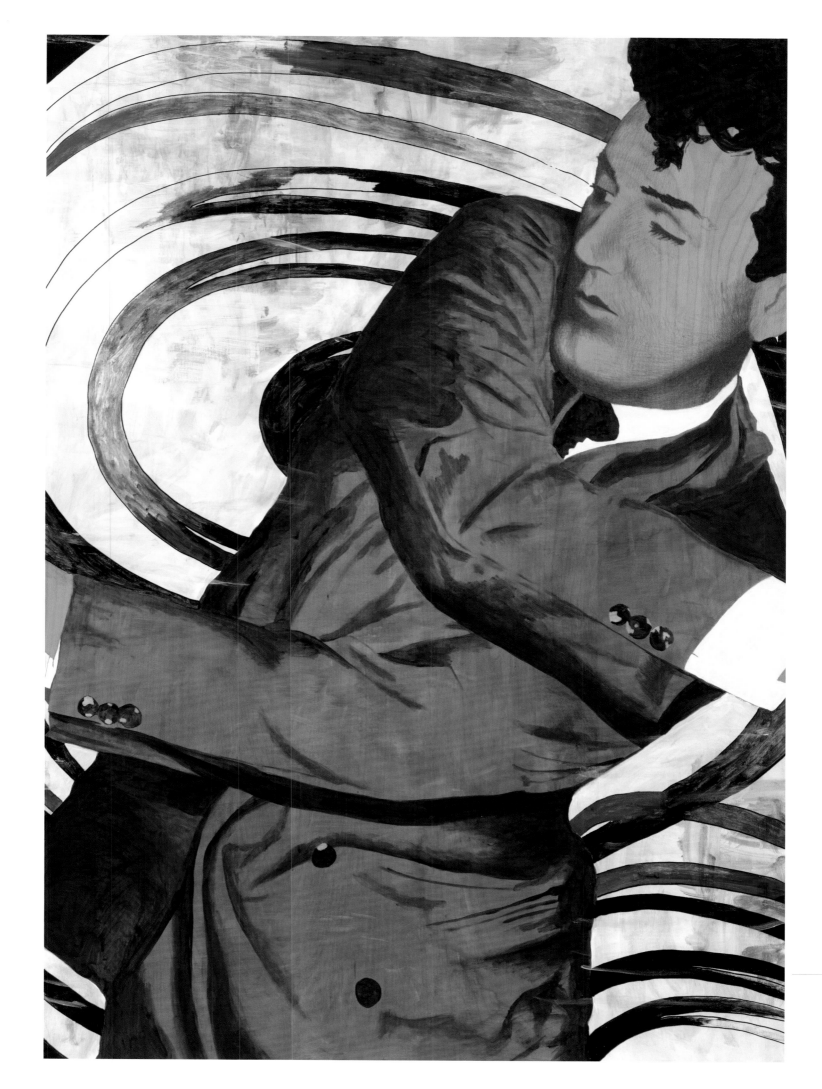

Ich könnte mich ohrfeigen (rechts), 2004

ROBERT LUCANDERS DOPPELBILDER: SPIEGELPHÄNOMENE UND ZAUBERTRICKS. BEATE ERMACORA

Obwohl die Motive für Robert Lucanders Bilder vorgefundenem Material entstammen, ist er kein Künstler, der Medienkritik üben will. Vielmehr ist er ein exzellenter, humorvoller Beobachter, der über Begriffe wie Original und Kopie nachdenkt und diese in seinen Werken auf originelle Weise unauflöslich miteinander verstrickt. Dies gerade angesichts von medialen Bildern zu tun, entbehrt nicht der Ironie, denn jeder weiß, dass sich die Protagonisten aus Politik, Werbe- und Modebranche sowie diverser Musik- und Kunstschauplätze für ihr Publikum inszenieren. Sie haben gelernt, sich für die Medien zu positionieren, um eine bestimmte Botschaft zu übermitteln. Und die Medien wissen, wie sie Personen so wiedergeben können, dass sie im rechten Licht erscheinen. Dabei geht es meist weniger um das, was die Menschen sagen, als um ihre Körperhaltungen, ihre Gesten und ihre Mimik. Körpersprache wird nicht nur im Genre von Film oder Fotografie als Rollenmuster trainiert, sondern ihr Erlernen bildet einen wichtigen Baustein in Managementseminaren. Robert Lucander setzt seine Kunst genau an der Schnittstelle an, an der der »Alltagsmensch« treuherzig zu glauben beginnt. Für seine Arbeiten greift er jedoch meist nicht die glamourösen, sensationellen Seiten des Bildjournalismus auf, sondern bedient sich ihrer Nebenprodukte, der Bilder der Boulevardpresse, der billigen Frauenzeitschriften, der Arzt- und Heimatromane oder anderer Drei-Groschen-Hefte, die stets bestimmten Schemata folgen. Auch Plattencover gehören zu seinen bevorzugten Sammelobjekten. Seine Bildvorlagen fungieren in den jeweiligen Medien als illustrative Leitmotive, um den Leser oder Hörer suggestiv auf die Lektüre oder die Musik einzustimmen und bereits im Vorfeld das Gefühl von Spannung oder Sehnsucht zu erzeugen. Ihn interessieren der erzählte Vorder- und gedachte Hintergrund von medialen Bildern, wie er einmal in einem Interview formuliert hat.[1] Es ist immer die Diskrepanz zwischen Darstellung und Sprache, die Lucander reizt, bestimmte Motive zu bearbeiten und hinsichtlich ihrer Bildaussage zu befragen. So beginnt er die von den Bildern initiierten Geschichten neu zu erzählen.

Tauchen in Lucanders früheren Werken bereits ab und zu doppelte Motive in ein und demselben Bild auf, so untersucht er in seinen jüngsten Werkkomplexen die verschiedensten Möglichkeiten der Bildwiederholung geradezu systematisch. Vor allem im Aquarell, denn die Technik, bei der die Farben fließen und Zufälle einkalkuliert werden müssen, kommt ihm dabei entgegen. Ähnlich wie in den auf Holz gemalten Werken mit ihren großflächigen und in exakten Umrissen angelegten Figuren sind auch die 2005 entstandenen Papierarbeiten auf Wesentliches reduziert und von monumentalen Körpern und Gesichtern beherrscht. Benützt der Künstler

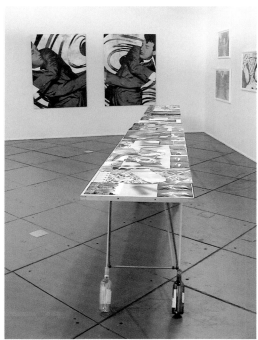

Ausstellungsansicht I As exhibited **Temporary Import,** Art Forum Berlin (28.09.–03.10.2005)

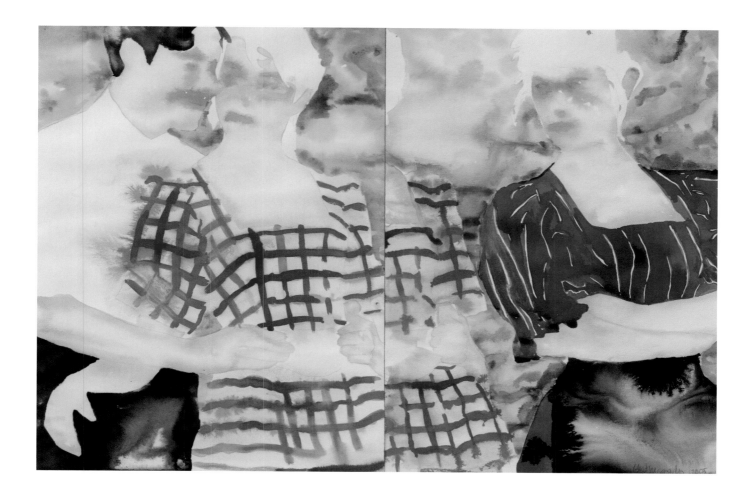

ROBERT LUCANDER'S DOUBLE IMAGES: MIRRORED PHENOMENA AND MAGIC TRICKS. BEATE ERMACORA

Even though the motifs for Robert Lucander's images come from found materials, he is not an artist whose interest lies in media critique. He is rather an excellent, humorous observer who reflects on terms such as original and copy, inextricably interweaving them into his works in a most original manner. Considering the way media images are, this is not something he does without irony, since everyone knows that people in politics, advertising, fashion and of course the various music and art scenes always try to present their audience with only one particular image of themselves. After all, they have learned how to position themselves in the media in such a way as to convey a certain message. And the media themselves know how to present these people so that they appear in the correct light. All of this has less to do with what these people have to say and more with their body language, their gestures, and facial expressions. Body language is not just learned as a tool of role play in the film or photography genre, but is an important building block in management seminars too. Lucander positions his art precisely at that point at which an 'ordinary' person's heartfelt belief begins. However, he does not as a rule use the glamorous, sensational pages of popular journalism in his works, but instead avails himself of their byproducts, such as images from gossip magazines, inexpensive women's magazines, penny romances and other cheap novels that always follow a certain set pattern. Record covers are another item he likes to collect. The images he bases his works on function in each medium as illustrative leitmotifs intended to get the reader or listener in the mood to read the book or listen to the music, to generate a feeling of suspense or longing. Lucander is interested in the narrative foreground and conceptual background of media images, as he once said in an interview.[1] It is always the discrepancy between presentation and language that moves him to work on particular motifs and to question their visual statements. And so he begins to retell the stories triggered by the images.

In some of Lucander's earlier works, twin motifs occur within the same image, while in his most recent works, he systematically investigates the various possibilities offered by the notion of image repetition. These works are mostly watercolors, since this technique—in which the colors intermingle and coincidences have to be anticipated—is particularly well suited to this type of exploration. Like the works painted on wood, with their large-area, precisely outlined figures, the works on paper done in 2005 are

in den Gemälden die Maserung des Holzes, um Hintergrund und Darstellungsgegenstand miteinander verschmelzen zu lassen, so treffen wir auch in den Papierarbeiten immer wieder auf ähnlich fließende Übergänge, die Raumsituationen verunklären und die oft nur schemenhaft angedeuteten Menschen und Objekte mit ihrer Umgebung eins werden lassen.

Lucanders Bilder kreisen um Fragen von Schein und Wirklichkeit, Lüge und Wahrheit. »Mich interessiert die Entwicklung der Darstellungskonventionen, die in Pressebildern ablesbar ist. Wir sehen neue Bilder und dadurch können wir etwas Neues über unsere Zeit erfahren. Das versuche ich in meine Bilder mitzunehmen.«[2] Er setzt also nicht bei Bildern und Geschichten an, die vielleicht wirklich etwas über Authentizität erzählen könnten, sondern bei jenen, die überzeugen und überreden wollen oder als Klischeebilder eine idyllische, herbeigesehnte heile Welt vermitteln sollen. Gleich drei Mal gibt er eine finnische Schlagersängerin wieder, deren Kommentare zu ihrem Leben das beigegebene Bild in höchste Widersprüche verwickeln *(Mieli vetää taas maailmalle* [Ich habe Lust gehabt, in die Welt zu ziehen], 2005, Abb. S. 82). Ihrer Sehnsucht nach Lappland gibt sie Ausdruck, indem sie im nordisch gemusterten Pullover einen Birkenstamm umarmt. Wie lässt sich dies nun aber mit ihrer Aussage vereinbaren, dass sie lieber in der Stadt lebt und nicht gerne allein ist? Die Farben der Aquarellfolge changieren von einem Blatt zum anderen und das wohl ursprünglich überzeugend lächelnde Gesicht nimmt aufgrund der diffundierenden Binnenzeichnung zunehmend monströse, verzweifelte Züge an, wodurch die kokette Umarmung des Baumes in eine einsame Geste des Haltsuchens am Mythos und Kraftspender Wald umkippt. Lucander liebt es, genau diese Ungereimtheiten wortwörtlich abzubilden. Durch das Herausheben aus ihrem Bild-Textzusammenhang beschwört der Künstler entlarvende, mitunter skurrile Situationen herauf. Denn auch *Lady Chatterley* (2005, Abb. S. 78 hinten links oben), die eine leidenschaftliche Affäre mit dem Förster ihres Mannes hat, umarmt statt des Liebhabers stellvertretend für dessen Metier einen Baum. Eine andere Arbeit, die aus jeweils zwei Doppelbildern besteht, wurde von der merkwürdigen Geschichte eines Finnen inspiriert, der als englischer Kriegsgefangener in Mombasa das Seiltanzen lernte. Lucanders Vorlage zeigt ihn, wie er ein paar Zentimeter über dem Boden auf einem zwischen Bäumen gespannten Seil balanciert. In einer der Bilddoppelungen scheint er jubelnd die Arme in die Luft zu werfen, in der anderen fasst er sich, gleichsam bei sich selber Halt suchend, an der Hand. Im Gegensatz zu den Pathosgesten der Frauen vollführen die Männer eher ungelenke Bewegungen, die leise auf sich aufmerksam zu machen suchen. Oft tragen sie als Synonym für ihre Bodenständigkeit und Naturverbundenheit karierte Hemden.

reduced to the bare essentials and dominated by monumental bodies and faces. In the paintings on wood, the artist uses the grain to meld the background with the object portrayed. In the works on paper, meanwhile, we frequently encounter similarly fluid transitions that distort the spatial situations in such a way as to cause the people and objects depicted—often by no more than an outline—to blend in with their surroundings.

Lucander's images are concerned with questions of appearance and reality, lies and truth. "I'm interested in the development of portraiture conventions evident in press photos. We see new images and, through them, can experience something new about our era. This is what I try to bring into my pictures."[2] He does not begin with images and narratives that might really say something about authenticity, therefore, but rather with those whose aim is to convince, to persuade, or to convey clichéd images of an idyllic, desirable, perfect world. Lucander has repeated three images of a Finnish pop singer, whose own comments on life seem to be completely at odds with the image she projects *(Mieli vetää taas maailmalle* [I wanted to go out into the world], 2005, fig. p. 82). She expresses her longing for Lapland by wearing a sweater with a Nordic pattern and embracing the trunk of a beech tree. Yet how can this be reconciled with her claim that she prefers to live in a city and does not like to be alone? The colors in this watercolor series change from one sheet to the next, while the face that smiled more or less convincingly at first gradually takes on monstrous, almost desperate traits owing to the intermingling of the lines drawn into it. The flirtatious embrace of the tree becomes the lonely gesture of someone trying desperately to draw strength from the mythical and life-giving power of the forest. These are the inconsistencies that Lucander loves to literally reproduce. By taking them out of their image-text context, the artist conjures up some revealing, in some cases comical, situations. For even *Lady Chatterley* (2005, fig. p. 78, rear wall top left), who is having a passionate affair with her husband's gamekeeper, hugs a tree as a symbolic stand-in for her lover. Another work consisting of two pairs of double images was inspired by the strange story of a Finnish man who learned how to walk a tightrope while a prisoner of war of the English in Mombasa. Lucander shows him balancing a couple of centimeters off the ground on a rope suspended between two trees. While in one of the images he seems to be throwing up his arms in jubilation, in the other, he is holding his own hand as if trying to keep his balance. In contrast to the emotional gestures of his women, Lucander's men act rather clumsily and in doing so subtly draw attention to themselves. They are often shown wearing checkered shirts as a synonym for their down-to-earthness and love of nature.

Die Figuren, die uns Lucander in diesen Serien und Doppelsequenzen vorführt, sind nicht mehr die strahlenden Helden ihrer Geschichten, deren Handeln von Selbstgewissheit geprägt ist. Der Künstler überlistet sie gleichsam mit einem Trick. Er dupliziert ihre Handlungen, setzt Gesten in einem zweiten Bild falsch an oder lenkt ihre Blicke, die ursprünglich auf jemand anderen gerichtet waren, auf sie selbst zurück. So transportiert er triviale, kitschige, von jedermann leicht lesbare und durchweg langweilige Bildsujets in eine andere Erzählstruktur und Richtung. Den gekünstelten und auf bestimmte Emotionen hin getrimmten Menschen seiner fotografischen Vorlagen attestiert er Eigenleben und reflexives Verhalten. Mit dem banalen Ausgangsmaterial und seinen an filmische Montagen erinnernden Bildern unternimmt er unvermutet eine Reise in die Welt der Psychologie. Vergleichbar der Dramaturgie eines David Lynch,[3] der zunächst schöne glatte Oberflächen präsentiert, um den Betrachter umso tiefer durch deren Risse in unentwirrbare Schatten- und Doppelwelten blicken zu lassen, konfrontiert Lucander seine Protagonisten mit sich selbst. Viele begegnen sich in ihren Spiegelbildern wieder. In fast allen Synchrondarstellungen stellen wir jedoch Unterschiede fest. Die Perspektive ist um Nuancen verrückt, Kleidung und Hintergrund haben die Farben gewechselt, Figuren sind hinzugekommen oder ausgeblendet worden und Zeitebenen scheinen sich verschoben zu haben.

Sogar *Hector El Neco* (2005), der berühmte schwedische Zauberkünstler muss die gezinkten Karten gegen sich selber ausspielen. Mit skeptischem Blick versucht er sich selbst zu überlisten. Oder übt er nur seine Fingerfertigkeit und seine Wirkung auf das Publikum vor dem Spiegel? Wir erinnern uns an die Szene mit Kultstatus aus Martin Scorseses *Taxi Driver*,[4] als Robert De Niro mit gezücktem Revolver vor einem Spiegel steht und sein vermeintliches Gegenüber mit einem wiederholten »You talkin' to me?« zum Duell auffordert. Robert Lucanders Spiegelbilder zeugen nicht von Narziss, der sich naiv in sein eigenes Antlitz verliebt.[5] Sie sind bereits weit hinaus über das erste Spiegelerlebnis des Kindes und verwechseln nicht mehr das Bild mit der Wirklichkeit.[6] Vielmehr scheinen sich die meisten dargestellten Personen der Ausweglosigkeit einer Selbstkonfrontation bewusst zu sein, wie die Frau in *Diagnose Eifersucht* (2005). Hier wie in vielen anderen Arbeiten auch zitiert der Titel eine Bildunterschrift oder die Coverheadline eines Romanheftes. Was der Künstler bei der Wiedergabe seiner Bildvorlagen weglässt, bleibt sein Geheimnis. Bei dem in symbolträchtigem Grün gehaltenen Doppelporträt befragt die eifersüchtige Frau ihr eigenes Bildnis. Kann man aber auf sich selbst eifersüchtig sein? Zwar erscheint das eine klarer, das andere verwischter – bei welchem es sich nun aber um das vermeintliche Bild der Wirklichkeit und bei welchem um das Spiegelbild handelt, bleibt völlig ungewiss. Während der magische

The figures Lucander shows us in these series and double sequences are no longer the beaming heroes of their own stories, whose actions are characterized by self-assurance. The artist tricks them, as it were. He duplicates their actions, adds a wrong gesture to a second image, or directs their gaze—originally aimed at someone else—back to themselves. In this way, he transplants trivial, kitschy, readily understandable and generally boring visual subjects into a different narrative structure and so turns them in a different direction. The artificial people with their rehearsed emotions shown in the photographs he uses as the basis for his work are given back their own lives and reflexive behavior. With his banal raw materials and images that recall film montages, Lucander unwittingly undertakes a journey into the world of psychology. Using a dramaturgic method much like that of David Lynch,[3] who at first presents beautiful, smooth surfaces so that viewers can see even deeper into the cracks and into the complex world of shadows and doubles underneath, Lucander confronts his protagonists with themselves. Many of them encounter themselves again in their own mirror images. In almost all of these synchronized portraits, however, we can see differences. A slight nuance has altered the perspective perhaps, or the clothing and background have changed color; figures may have been added or removed, and levels of time may seem to have shifted.

Even *Hector El Neco* (2005), the famous Swedish magician, has to play against himself with marked cards. Looking rather skeptical, he tries to trick himself. Or is he simply keeping his fingers in shape and trying to see in the mirror what his effect on his audience might be? We are reminded of a scene in Martin Scorsese's cult movie, *Taxi Driver*,[4] in which Robert De Niro stands in front of a mirror with a drawn revolver, challenging an imaginary opponent by repeatedly asking "You talkin' to me?" Lucander's mirror images have nothing to do with Narcissus, who fell in love with his own face.[5] They are already far beyond the child's first experience of the mirror and no longer confuse image with reality.[6] Rather, most of the people portrayed seem to be aware of the dead-end of self-confrontation, like the woman in *Diagnose Eifersucht* (Diagnosis jealousy, 2005), for example. Here, as in many other works, the title is also a quotation, perhaps of a photo caption or of a line from the cover of a novel. Whatever the artist has left out in his reproduction of the image remains his secret. In this double portrait, captured in symbolic green, the jealous woman questions her own image. Yet can one be jealous of oneself? Even though one seems to be clearer, the other more blurred, we cannot be certain which image is supposed to be the reality and which the reflection. While the magic mirror in *Schneewittchen* (Snow White)

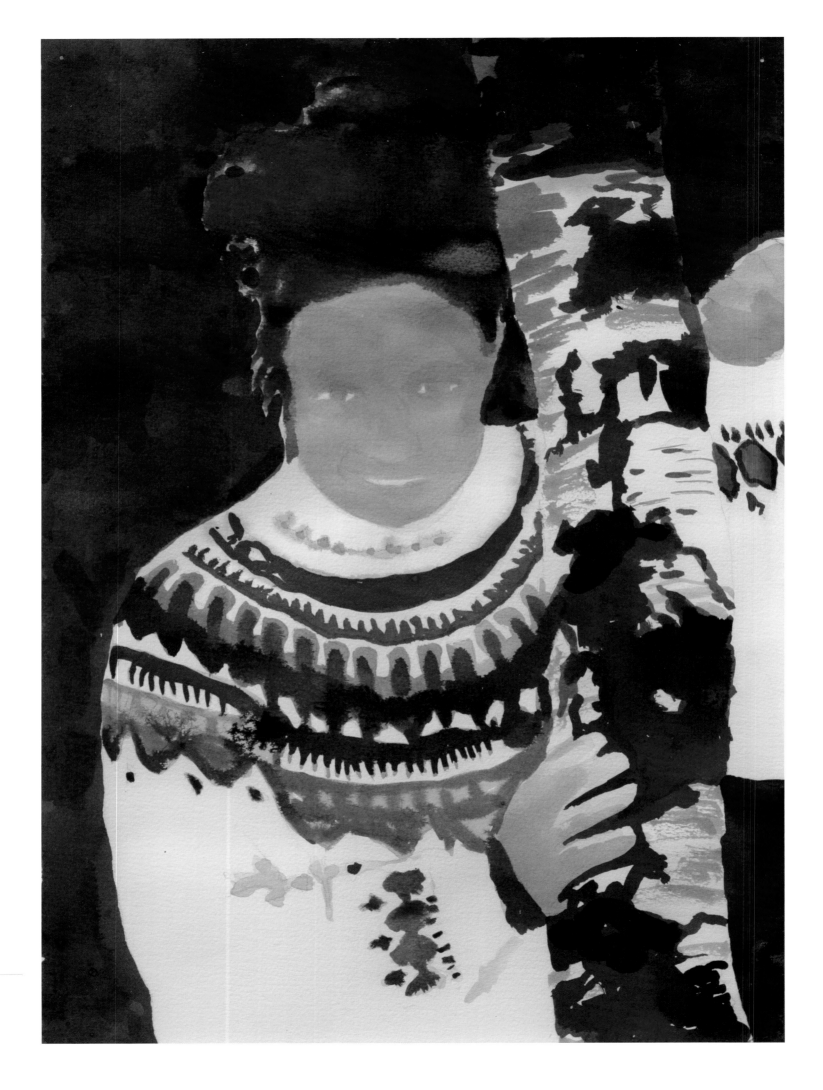

Spiegel in *Schneewittchen* der Königin auf deren Frage nach der Schönsten im ganzen Land ein anderes Gesicht als das ihre zeigt, bleibt in unserem Fall der Spiegel, was er ist. Ein optisches Instrument, das das Bild derjenigen zurückwirft, die in ihn hineinblickt.

In irgendeiner Weise beobachten sich in Lucanders Diptychen die Personen immer. Dabei erscheinen viele Bilder mit ihren verlorenen Gesichtern wie Traumbilder, in denen man sich dramatische Situationen wieder vor Augen holt. In *Das Unglück hat sie nicht gewollt* (2005, Abb. S. 86) beugt sich eine Frau zweimal über einen, wie wir aufgrund des Titels vermuten, nicht Schlafenden, sondern Toten. Die Haltung ist dieselbe, das Dirndl hat die Farben gewechselt, Haar- und Pulloverkolorit des Liegenden sind vertauscht, das Geschehen ist einmal näher, einmal weiter weggezoomt. Wie in dem Film *Und täglich grüßt das Murmeltier*,[7] in dem der Protagonist unzählige Male ein und denselben Tag durchleben muss, scheinen auch Lucanders Doppelgänger die Chance der Wiederholung zu bekommen, um ihr Handeln zu überdenken und zu verbessern. Gerade in Sequenzen, in denen die Hauptakteure mit anderen zusammen und in Handlungen involviert sind, ist man an Räume erinnert, in denen etwa Spiegel über Eck angebracht sind. Als außen stehender Betrachter erhielte man von einer bestimmten Position aus nur ein einziges Bild. Würde man sich aber etwas drehen, so stellten sich manche Situationen, die man als eindeutig empfunden hat, sicherlich anders dar. Sind etwa in der einen Bildhälfte Personen bloß angeschnitten und dadurch als nebensächliche Randfiguren ausgewiesen, so erscheinen sie in der anderen prominent auf der Bildfläche. Gesten oder ein Gesichtsaus-

answers the question of who is the fairest of them all by showing the queen a different face, in our case, the mirror remains what it is—an optical instrument that reflects the image of the person looking into it.

The people in Lucander's diptyches are always observing themselves in one way or another and many of the pictures with their lost faces seem like dream images, in which dramatic situations are relived. In *Das Unglück hat sie nicht gewollt* (She didn't want the accident, 2005, fig. p. 86), a woman is twice shown bending over someone who, thanks to the title, we suspect is not sleeping, but dead. The pose is the same in both images, except that in one, the color of the dirndl is different and the colors of the reclining figure's hair and sweater have been switched. In one image, the events are closer; in the other, further away. As in the film *Groundhog Day*,[7] in which the protagonist has to live through the same day over and over again, Lucander's doppelgangers also seem to have an opportunity to repeat themselves, to rethink and perhaps correct their actions. Those sequences in which the main characters are involved both with others and with their actions are particularly reminiscent of rooms containing mirrors hung on perpendicular walls. Standing in a certain position, the outside viewer sees only one particular image. Yet he has only to turn slightly and situations that might have seemed perfectly clear suddenly seem quite different. People who in one half of the picture are shown only in part and so made to seem insignificant, marginal figures, are suddenly given pride of place in the other. This in turn causes their gestures or facial expressions to take on a completely different meaning.

Puttomilla tuntureilla, 2005
Das isses, 2005

83

druck erhalten so plötzlich völlig andere Bedeutungen. Robert Lucander setzt dieses Moment des Perspektivwechsels spielerisch in Szene, indem er in einem Bild etwa eine Frau neben einem Mann platziert. Erst das zweite Bild zeigt, dass sich an dessen Schulter wiederum eine andere lehnt. Indem er mit Ausschnitten arbeitet, kommt es immer zu einem unerwarteten Umkippen und damit zu einem völlig offenen Ende von spannungsgeladenen Geschichten, die eigentlich keine sind. Gleichwohl gezielt wie geschickt lenkt der Künstler unsere Aufmerksamkeit auf die Tatsache, dass Bilder und die menschliche Körpersprache je nach Kontext immer anders und neu gedeutet werden müssen und nichts so ist, wie es scheint.

Robert Lucanders Lust am Kuriosen und Merkwürdigen, an Zaubertricks, Spiegelphänomenen und optischen Vortäuschungen, die Unmögliches scheinbar möglich machen, findet in einem jüngst entstandenen Gemälde (2006, Abb. S. 90/91) seine prägnante Ausformulierung: Ein einsamer Rentner spielt leidenschaftlich mit Figuren in den Farben der deutschen Flagge Schwarz-Rot-Gold gegen sich selbst *Mensch ärgere Dich nicht.*

Anmerkungen

1 Jan-Hendrik Wentrup, »Im Gespräch mit Robert Lucander«, in: *Berlin North*, Ausst.-Kat. Nationalgalerie im Hamburger Bahnhof, Museum für Gegenwart, Berlin 2004, S. 5. I 2 Robert Lucander. Sven Drühl, »›Man muss nicht nur die schönen Seiten zeigen, es gibt auch andere.‹ Ein Gespräch«, in: *Kunstforum International*, Bd. 174. Januar–März 2005, S. 247. I 3 In David Lynchs Fernsehserie *Twin Peaks* (1990) etwa verweist bereits der Titel auf eine Unzahl von Verdoppelungen. Die Serie handelt »[…] von doppelbödigen Personen voller Geheimnisse, die sich psychisch nicht von ihrer Umwelt abgrenzen können. […] Die Verdoppelungen erinnern auch an die fließenden Grenzen zwischen Ich und Du, Innen und Außen, Gut und Böse, und sie werden Symbole für das Verdrängte und dessen zahlreiche Erscheinungsformen.« Anna Jerslev, *David Lynch. Mentale Landschaften*, Wien 1996, S. 183. I 4 Vgl. Martin Scorsese, *Taxi Driver*, USA 1976. I 5 Vgl. Maren Welsch, *Vom Narziss zum Narzissmus. Mythos und Betrachter. Von Caravaggio zu Olaf Nicolai*, Diss., Kiel 2002. I 6 Vgl. Jacques Lacan, »Das Spiegelstadium als Bildner der Ichfunktion«, in: ders., *Schriften I*, Olten/Freiburg im Breisgau 1973. I 7 Vgl. Herold Ramis, *Und täglich grüßt das Murmeltier*, USA 1992.

Lucander playfully stages this moment of changed perspective by placing a woman next to a man, for instance, and then waiting until the second image before revealing that there is another woman leaning on the man's shoulder. Because he works with excerpts, things always take an unexpected turn, making for completely open endings to suspense-laden stories that are actually nothing of the sort. Yet in a way that is as deliberate as it is clever, the artist also draws our attention to the fact that images and human body language vary and must be reinterpreted according to their context and that nothing is what it seems.

Lucander's passion for the curious and the strange, for magic tricks, mirrored phenomena, and optical illusions that seem to make the impossible possible is expressed with great succinctness in a very recent painting called *Mensch ärgere Dich nicht* (2006, fig. p. 90/91); this shows a lonely pensioner fervently playing a game of Frustration against himself with figures colored black, red and gold—the colors of the German flag.

Notes

1 Jan-Hendrik Wentrup, "Im Gespräch mit Robert Lucander," *Berlin North*, exh. cat., Nationalgalerie im Hamburger Bahnhof, Museum für Gegenwart, (Berlin, 2004), p. 5. I 2 Robert Lucander. Sven Drühl, "'Man muss nicht nur die schönen Seiten zeigen, es gibt auch andere.' Ein Gespräch," *Kunstforum International*, vol. 174 (January/March 2005), p. 247. I 3 In Lynch's television series, *Twin Peaks* (1990), for example, even the title implies countless duplications. The series is ". . . about two-faced people full of secrets who cannot close themselves off psychically from their environment. . . . These doublings also recall the shifting boundaries between you and I, internal and external, good and evil, and they become symbols for that which is repressed and all its many manifestations." Anna Jerslev, *David Lynch. Mentale Landschaften* (Vienna, 1996), p. 183. I 4 See Martin Scorsese, *Taxi Driver*, (USA, 1976). I 5 See Maren Welsch, *Vom Narziss zum Narzissmus. Mythos und Betrachter. Von Caravaggio zu Olaf Nicolai*, diss. (Kiel, 2002). I 6 See Jacques Lacan, "Das Spiegelstadium als Bildner der Ichfunktion," Lacan, *Schriften I*, (Olten/Freiburg im Breisgau, 1973). I 7 See Herold Ramis, *Groundhog Day*, (USA, 1992).

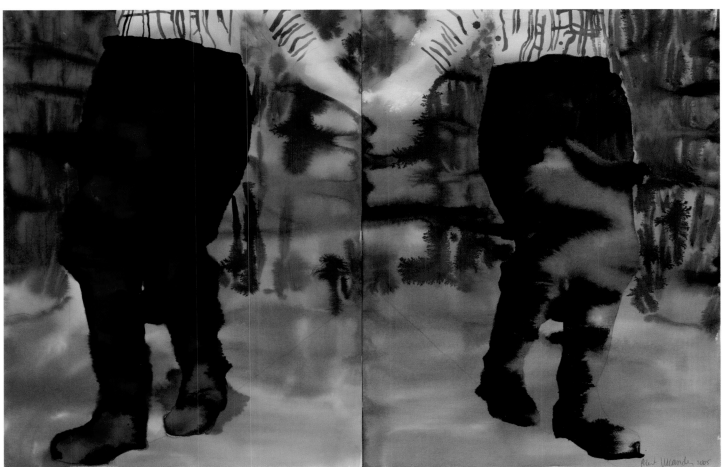

Erkki tunnustaa, 2005
opittu harrastus, 2005

 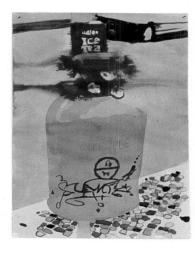

 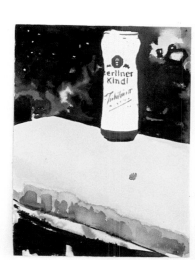

Mensch ärgere Dich nicht. West und Ost, 2006

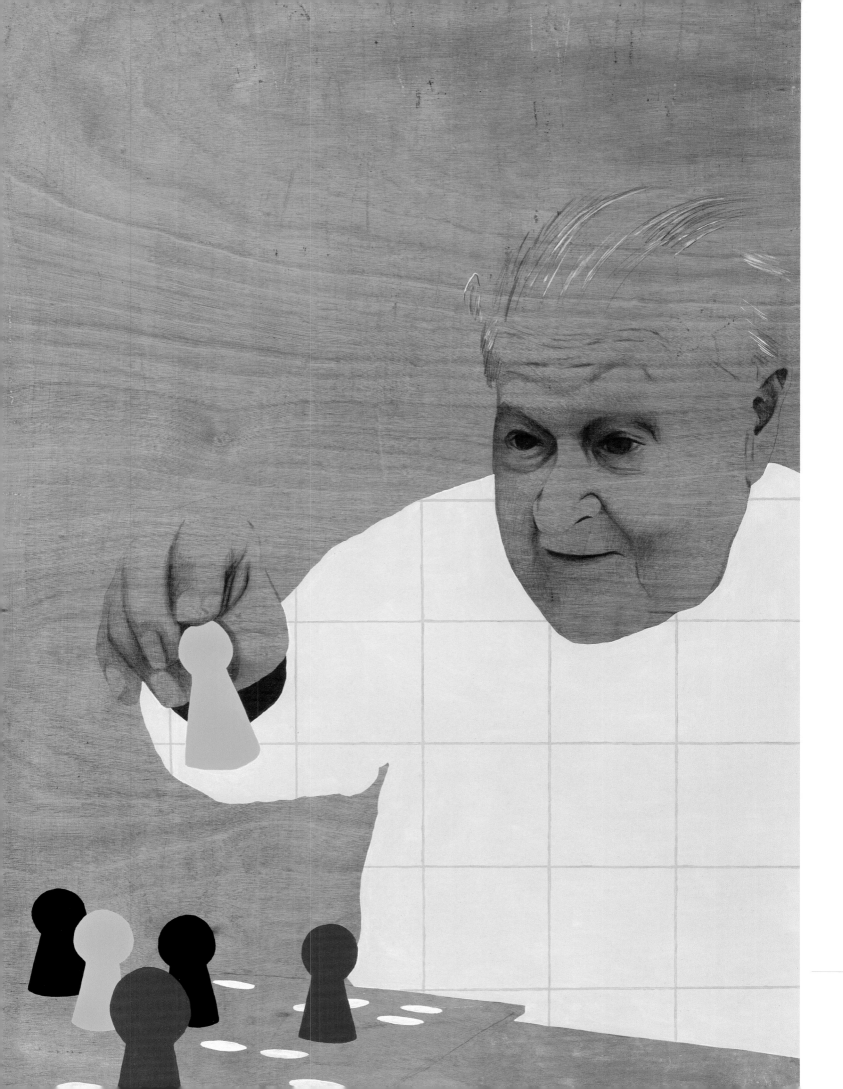

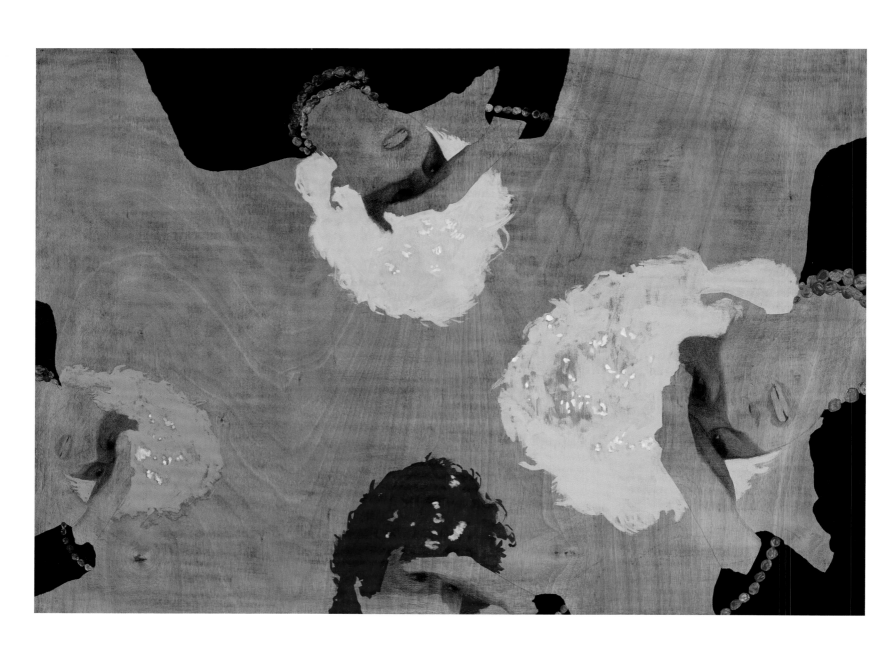

Immer hautnah dabei, 2006

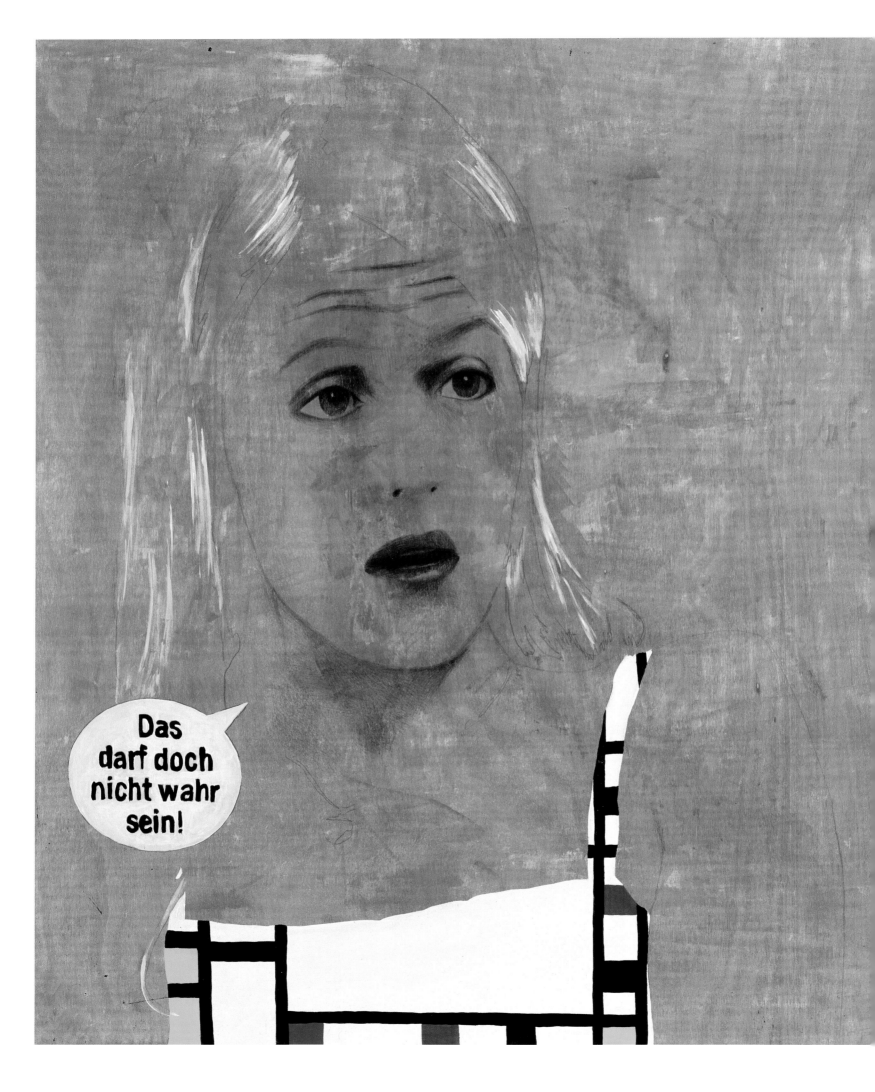

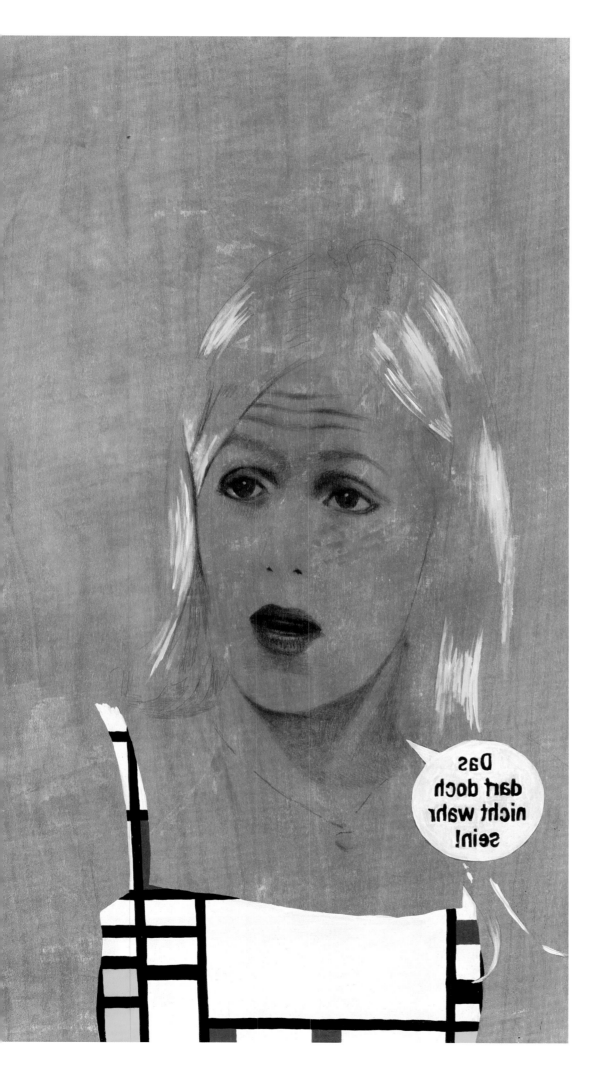

Das darf doch nicht wahr sein, 2006

BIOGRAFIE BIOGRAPHY

Robert Lucander
geb. I born 1962 in Helsinki
lebt und arbeitet I lives and works in Berlin

Studium Education
1989–1995 Hochschule der Künste, Berlin

Preise und Stipendien Prizes and Awards
1998 Stina Krooks Stiftelse
1994 Young Art Finland-Prize

Einzelausstellungen Solo Exhibitions
(K) = Katalog I Catalogue

2006
Cocktail International – Instrumental, Museum Baden, Solingen (K)
Cocktail International – ALLES ORIGINAL REMIX, Kunstmuseum Mülheim an der Ruhr in der Alten Post (K)
Cocktail International – Los Grandes Exitos, DA 2 Domus Artium 2002, Salamanca

2005
Liebe isst, Künstlerverein Malkasten, Düsseldorf

2004
Robert Lucander. Evanescences, Vitamin Arte Contemporanea, Turin (K)
Eva könnte es ins Internet stellen, Galerie Anhava-Korjaamo, Helsinki
I Made Sweden, Milliken, Stockholm
Hör zu – Sing mit, Galerie Krobath Wimmer, Wien

2003
Finlandia, Contemporary Fine Arts, Berlin

2002
The Second Coming, Bergen Kunsthall
Warum bellen, wenn man auch beissen kann, Galerie Anhava, Helsinki

2001
Alibi, Contemporary Fine Arts, Berlin
Robert Lucander. Party with attitude – Sait mitä hait, Turun taidemuseo, Turku; Institut Finlandais, Paris; Amos Anderson taidemuseo, Helsinki (K)

2000
Oops ... I did it again, Galleri Tommy Lund, Kopenhagen
Knock on Wood, Contemporary Fine Arts, Berlin
TACK, Galleri Krister Fahl, Stockholm

1999
Mittendrin statt nur dabei ... says amazing new research!, Galerie Anhava, Helsinki

1998
Och nu en gång på riktigt, Robert Lucander, Ystads Konstmuseum
Looking terrific, eller allt det som ögat vil se, Galleri Bergman, Göteborg

1997
Robert Lucander, Park-Klinik, Berlin
En stor stark, Galleri German, Malmö
Hitparaden, Galerie Du Nord, Bohus
Believe it or not, Galleri Krister Fahl, Stockholm
Top 10, Gelbe Musik, Berlin

1996
Robert Lucander, Galeriehaus Werner Weinelt, Hof
Meine grossen Erfolge, Galerie Anhava, Helsinki

1995
Riktiga bilder, Galleri Fabriken, Göteborg

1994
Orginalstora arbeten i DIN-format, Forumgalleriet, Malmö

Robert Lucander, Galleri Krister Fahl, Stockholm
Robert Lucander, Galerie Anhava, Helsinki (K)

1993
Robert Lucander, Galerie von der Tann, Berlin
Robert Lucander, Galeriehaus Werner Weinelt, Hof

1992
Robert Lucander, Galerie Bellarte, Turku (K)
Robert Lucander, Galerie Anhava, Helsinki

Gruppenausstellungen Group Exhibitions
(K) = Katalog I Catalogue

2006
Pictorial Research, art agents, Hamburg
Kick-off Berlin. Art Makes the World, Haus am Waldsee, Berlin
Painting as presence, Künstlerhaus Bethanien, Berlin

2005
Goethe abwärts. Deutsche Jungs etc. – The Falckenberg Collection, Helsingin kaupungin taidemuseo, Taidemuseo Meilahti, Helsinki (K)
Temporary Import, ART FORUM BERLIN 05 (K)
Turku Art Museum – 101 Years of Contemporary Art, Turun taidemuseo, Turku
Colours and Trips, Künstlerhaus Palais Thurn und Taxis Bregenz; Museum der Stadt Ratingen (K)

2004
Central Station – La collection Harald Falckenberg, La maison rouge – Fondation Antoine de Galbert, Paris
Victoria Miro, Warehouse, London
L'Arte in Testa, Museo Arte Contemporanea Isernia (K)
Berlin-North, Nationalgalerie im Hamburger Bahnhof, Museum für Gegenwart, Berlin (K)
Carnegie Art Award – 2004, Kópavogur Art Museum; Kunstnernes Hus, Oslo; Charlottenborg, Kopenhagen (K)

2003
Carnegie Art Award – 2004, The Royal Academy of Fine Arts, Stockholm (K)
Prague Biennale 1, The peripheries become the center, National Gallery, Prague (K)
Over The Horizon, Malmö Konstmuseum

2002
Popcornia ja politiikkaa, KIASMA, Helsinki (K)
Stop for a Moment – Painting as Narrative, Istanbul Museum of Contemporary Art (K)
Montags. Klasse Marwan, Universität der Künste, Berlin (K)
An der Schwelle des Unbekannten, Bayer Kulturabteilung, Leverkusen
Friede, Freiheit, Freude, Galerie Guido W. Baudach/ Maschenmode, Berlin
Künstler helfen alten und neuen Meistern, Neue Nationalgalerie Berlin
Myytti – matka suomalaiseen mielenasemaan, Helsingin kaupungin taidemuseo, Taidemuseo Meilahti, Helsinki

2001
Watch me ..., American-European Fine Art, New York
Kunstpreis der Böttcherstraße in Bremen 2001, Kunsthalle Bremen (K)

2000
Taidepuutarha, Töölöönlahti 2000, Helsinki (K)
Labyrintti, Helsingin taidehalli, Helsinki (K)
Soft Parade, Skövde Konsthall

1999
Europa Artline, Borken
Presentation-Grafik från Atelje' Larsen, Tomarp Kungsgård, Kvidinge

1998
Vattenvägar – Ars Baltica, Ystads Konstmuseum (K)
Kommando Ketchup-Berlin, Linköpings Konsthall (K)
Sommarminnen, Galleri Bergman, Göteborg
Nordische Grüße, St. Johannes-Kirche, Lüchen

1997
Blomstermålningar, Galerie Artek, Helsinki
Till Jönköping, Jönköpings Länsmuseum
Excudit, Atelje' Larsen, Vikingbergs Konstmuseum, Helsingborg

1996
Enter, Helsingin taidehalli, Helsinki
Original Copy, Helsingin taidehalli, Helsinki (K)
Grafik och Multiplar, Galerie Anhava, Helsinki
New Edition, Galleri Leger, Malmö
Smart-Show 96, Galleri Krister Fahl, Stockholm; Wasahallen, Stockholm

1995
Auf der Suche nach einem Lagerraum, Nürnberger Kunstverein
Här var annars?, Pakhuset, Nyköbing, (K)
Grafik från Atelje' Larsen, Galleri Bergman, Göteborg/Karlstad
10 Jahre Nürnberg Eck, Nürnberg Eck, Berlin
Finsk Måleri, Galleri Wang, Oslo/Stavanger
Smart-Show 95, Galleri Krister Fahl, Stockholm; Wasahallen, Stockholm
A Bonnie Situation, Contemporary Fine Arts, Berlin

1994
Mustaa ja valkoista, Galerie Anhava, Helsinki
Postkonzeptuelle Malerei II, Startblock, Kunst-Werke, Berlin
Lukea, att läsa, reading, Galleri Augusta, Helsinki

1993
Arbetsnamn: Sommarnatt, Nordic Art Centre, Helsinki; Sundsvalls Art Museum;Tikanojas Konsthem, Vasa; Millesgården, Stockholm (K)

1992
Les seuls véritables 2, Ballhaus Carmenstraße, Berlin

1991
Klasse Marwan '91, Hochschule der Künste, Berlin
Les seuls véritables, Berlin, Atelierhaus Wilhelmstraße, Köln

BIBLIOGRAFIE AUSWAHL **BIBLIOGRAPHY** SELECTION

2006

New German Painting, hrsg. von I ed. by Christoph Tannert und I and Graham Bader, München.

2005

Sven Drühl, »›Man muss nicht nur die schönen Seiten zeigen, es gibt auch andere.‹ Ein Gespräch«, in: *Kunstforum International,* Bd. 174, Januar–März.
Brigitte Werneburg, »Der vorübergehende Einfluss«, in: *die tageszeitung,* 28. September.
Oliver Zybok, »Unintentional Meaning«, in: *Goethe abwärts. Deutsche Jungs etc. – The Falckenberg Collection,* Ausst.-Kat. I Exh. Cat. Helsingin kaupungin taidemuseo, Taidemuseo Meilahti.
Oliver Zybok, »Die Allgegenwärtigkeit der Aktualität«, in: *Colours and Trips,* Ausst.-Kat. I Exh. Cat. Künstlerhaus Palais Thurn und Taxis Bregenz; Museum der Stadt Ratingen, Frankfurt am Main.

2004

Luca Beatrice, »Helsinki – Berlin and Back. The Coolness of Robert Lucander«, in: *Robert Lucander. Evanescences,* Ausst.-Kat. I Exh. Cat. Vitamin Arte Contemporanea, Turin.
Luca Beatrice, »L'Arte in testa«, in: *L'Arte in Testa,* Ausst.-Kat. I Exh. Cat. Museo Arte Contemporanea, Isernia.
Matthias Geyer, »Der Kanzlerflüsterer«, in: *Der Spiegel,* Nr. 8, 16. Februar.
Marja Sakari, »Love me or leave me, favourites from the collection«, in: *Love me or leave me, favourites from the collection,* Ausst.-Kat. I Exh. Cat. KIASMA, Helsinki.
Jan-Hendrik Wentrup, »Im Gespräch mit Robert Lucander«, in: *Berlin North,* Ausst.-Kat. I Exh. Cat. Nationalgalerie im Hamburger Bahnhof, Museum für Gegenwart, Berlin.

2003

Gitte Lauströer, »Konst för djärva och unga«, in: *Hufvudstadsbladet,* October 8.
Sirkku Uusitalo, »Kesämökki kasvoi taloksi«, in: *Avotakka,* No. 2, February.
Anni Valtonen, »Kuusi suomalaista tavoittelee pohjoismaista taidepalkintoa«, in: *Helsingin Sanomat,* July 10.
Katrin Wittneven, »Wir geh'n voran«, in: *Der Tagesspiegel,* 17. Mai.

2002

Özlen Altunok, »Resimlerin de öykuleri vardir«, in: *Cumhuriyet,* May 3.
Mika Hannula, »Paint it Black«, in: *Flash Art,* October.
Mika Hannula, »Stop for a Moment – Painting as Narrative «, in: *Stop for a Moment – Painting as Narrative,* Ausst.-Kat. I Exh. Cat. Istanbul Museum of Contemporary Art.

2001

Iris Brennberger, »Der Kanzler und sein Bild«, in: *Berliner Zeitung,* 28. Juli.
Mika Hannula, »Sitä saat, mitä tilaat«, in: *Robert Lucander. Party with Attitude – Sait mitä hait,* Ausst.-Kat. I Exh. Cat. Turun taidemuseo, Turku; Institut Finlandais, Paris; Amos Anderson taidemuseo, Helsinki.
Angela Rosenberg, »Robert Lucander«, in: *Flash Art,* July–September.
Sigrid Schür, »Spannende Reise in die Gegenwartskunst«, in: *Die Welt,* 7. Mai.
Tim Sommer, »Malerei: Die neuen Realisten«, in: *art. Das Kunstmagazin,* Nr. 5, Mai.

2000

Corinna Daniels, »Hinterm Holz lockt das Nirwana«, in: *Die Welt,* 12. Mai.
Harald Fricke, »Robert Lucander«, in: *Artforum,* November.
Melitta Kliege, »Farbwechsel – Die Lackbilder von Robert Lucander«, in: *Robert Lucander. Accatone,* Ausst.-Kat. I Exh. Cat. Contemporary Fine Arts, Berlin.
Anja Lösel, »Glühende Bilderlust«, in: *Stern,* Nr. 40.
Christoph Tannert, »Robert Lucander«, in: *NU: The Nordic Art Review,* Vol. II, Nos. 3–4.

1999

Hans Burell, »En älsklingsutstallning«, in: *Göteborgsposten,* February 22.
Annika Hällsten, »Reklam för reklam«, in: *Hufvudstadsbladet,* January 21.
Marja-Terttu Kivirinta, »Robert Lucander jatkaa poplinjinjallaan«, in: *Helsingin Sanomat,* February 2.
Marja-Liisa Lappalainen, »Robert Lucander maalaa vaikka lenkkikengillä«, in: *Iltasanomat,* May 27.

1998

Patrick Annerud, »Berlin på passagen«, in: *Östgöta,* September 12.
Robert Dahlström, »Lekfull inledning på Vattenvägar«, in: *Ystads Allehanda,* June 12.
Örjan Olsson, »Kan dethar kallas för konst?«, in: *Skanska dagbladet,* June 12.
Seija Sartti, »Kaupallinen taide myy taas hyvin«, in: *Helsingin Sanomat,* October 10.

1997

Stefan Ersgård, »Robert Lucander«, in: *Arbetet Nyheterna,* November 9.
Mika Hannula, »Katsoa tarkkaan ja kunnella«, in: *Taide,* 3/97.
Peter Herbstreuth, »Reproduktion des Sichtbaren«, in: *Der Tagesspiegel,* 29. März.
Marja-Terttu Kivirinta, »Kukkia ja muita hillittomyyksiä«, in: *Helsingin Sanomat,* October 4.
Jyrki Simovaara, »Monimielinen katse«, in: *KIASMA,* 10/97.

1996

Gitte Lauströer, »Robert Lucander-Aktuell I Jönköping«, in: *Hufvudstadsbladet,* July 11.
Friedrich Meschede, »Versiegelte Welten«, in: *Robert Lucander,* Ausst.-Kat. I Exh. Cat. Galerie Anhava, Helsinki.
Ralf von Sziegoleit, »Malerei, deren Thema sie selber ist«, in: *Frankenpost,* 27. Dezember.

1995

Lena Form, »Livsfarlig lackfärg pa Fabriken«, in: *Göteborgs Posten,* April 29.
Harald Fricke, »Tiefengurgeln«, in: *die tageszeitung,* 25./26. Februar.
Peter Herbstreuth, »Warten auf Bonnie«, in: *Der Tagesspiegel,* 11. März.
Kaare Stang, »Finsk sisu med internasjonalt billespråk«, in: *Morgenbladet,* March 3–9.
Annika Winther, »Finlandsvens konstexport«, in: *Hufvudstadsbladet,* August 11.

1994

Gitte Lauströer, »Robert Lucander taiteilee Berliinin taivaan alla«, in: *Anna,* Nr. 10, March 8.
Kimmo Oksanen, »Kansainvälisesti tuettiin Suomipalkinnoin«, in: *Helsingin Sanomat,* December 12.
Rita Roos, »Konkreettinen ilmaisu ja maalaamaton reservi«, in: *Robert Lucander,* Ausst.-Kat. I Exh. Cat. Galerie Anhava, Helsinki.

1993

Curt Bladh, »En tillfällig treenighet«, in: *Sundsvalls Tidning,* October 24.
Peter Herbstreuth, »Kunstwelt Finnland«, in: *neue bildende kunst,* 6/1993.
Timo Valjakka, »Arbetsnamn: Sommarnatt«, in: *Arbetsnamn: Sommarnatt,* Ausst.-Kat. I Exh. Cat. Nordic Art Centre, Helsinki; Sundsvalls Art Museum; Tikanojas Konsthem, Vasa; Millesgården, Stockholm.

1992

Peter Herbstreuth, »Robert Lucander«, in: *SIKSI,* Nr. 4, 1992.
Seppo Lehtinen, »Osallistuja, kättelijät ja keramiikan taitaja«, in: *Turun Sanomat,* December 5.
Gertrud Sandqvist, »Robert Lucander«, in: *Robert Lucander,* Ausst.-Kat. I Exh. Cat. Galerie Bellarte, Turku.

Ausstellungskataloge Exhibition Catalogues

Robert Lucander – Cocktail International, hrsg. von I ed. by Oliver Zybok, Kunstmuseum Mülheim an der Ruhr in der Alten Post; Museum Baden, Solingen, Ostfildern 2006.

Goethe abwärts – Deutsche Jungs etc. The Falckenberg Collection, hrsg. von I ed. by Oliver Zybok, Helsingin kaupungin taidemuseo, Taidemuseo Meilahti = Helsinki kaupungin taidemuseo julkaisuja nro 87, Helsinki 2005.
Temporary Import, Art Forum Berlin 2005.
Colours and Trips, hrsg. von I ed. by Oliver Zybok, Künstlerhaus Palais Thurn und Taxis Bregenz; Museum der Stadt Ratingen, Frankfurt am Main 2005.

Robert Lucander. Evanescences, Vitamin Arte Contemporanea, Turin 2004.
L'Arte in Testa, Museo Arte Contemporanea, Isernia 2004.
Berlin North. Zeitgenössische Künstler aus den nordischen Ländern in Berlin – Robert Lucander. Social Situation, Nationalgalerie im Hamburger Bahnhof, Museum für Gegenwart, Berlin 2004.
Love me or leave me, favourites from the collection, KIASMA, Helsinki 2004.
Carnegie Art Award – 2004, Köpavogur Art Museum; Kunstnernes Hus, Oslo; Charlottenborg, Kopenhagen, Stockholm 2004.

Kunsträume im Norden, Galerie Asbaek/Bayer Kulturabteilung, Leverkusen, Kopenhagen 2003.
Art for Innovation, Robert Bosch GmbH, Stuttgart 2003.
Kunstgriffe. Helaba, hrsg. von I ed. by Juliane von Herz, Landesbank Hessen-Thüringen, Main Tower, Frankfurt am Main, Köln 2003.
Prague Biennale 1 – The peripheries become the center, National Gallery, Prague, Mailand 2003.

Popcornia ja politiikkaa, KIASMA, Helsinki 2002.
Künstler helfen alten und neuen Meistern, Neue Nationalgalerie Berlin 2002.
Stop for a Moment – Painting as Narrative, Proje 4L, Istanbul/NIFCA, Helsinki 2002.
Montags. Klasse Marwan, Universität der Künste, Berlin 2002.
Warum bellen, wenn man auch beissen kann, Galerie Anhava, Helsinki 2002.

Robert Lucander. Party with Attitude – Sait mitä hait, Turun taidemuseo, Turku; Institut Finlandais, Paris; Amos Anderson taidemuseo, Helsinki, Turku 2001.
Kunstpreis der Böttcherstrasse in Bremen 2001, Kunsthalle Bremen 2001.

iHOP, Lunds Konsthall 2000.
Robert Lucander. Accatone, Contemporary Fine Arts, Berlin 2000.
Labyrintti, Helsingin taidehalli, Helsinki 2000.

Vattenvägar – Ars Baltica, Ystads Konstmuseum 1998.
Kommando Ketchup-Berlin, Linköpings Konsthall 1998.

Robert Lucander, Galerie Anhava, Helsinki; Galleri Krister Fahl, Stockholm, Helsinki 1996.
Original Copy, Helsingin taidehalli, Helsinki 1996.

Här var annars?, Pakhuset, Nyköbing 1995.

Robert Lucander, Galerie Anhava, Helsinki 1994.

Arbetsnamn: Sommarnatt, Nordic Art Centre, Helsinki; Sundsvalls Art Museum; Tikanojas Konsthem, Vasa; Millesgården, Stockholm, Helsinki 1993.

Robert Lucander, Galerie Bellarte, Turku 1992.

Arbeiten in Sammlungen Works in collections

Achenbach Kunsthandel, München
Amos Andersons taidemuseo, Helsinki
Aros Securities Oy, Helsinki
Artcicolo e. V., München
Bayerische Hypotheken- und Wechselbank, München
Bob Kelly Collection, Göteborg
Bohus landsting
City of Espoo
Cohen Collection, Manchester
Deutsche Bank Collection, Frankfurt am Main
Doris and Helmut Lerchner Collection, Berlin
Falckenberg Collection, Hamburg
Forsa-Meinungsforschungsinstitut, Berlin
Gabriel Sulkowski Collection, Düsseldorf
Göteborgs Konstmuseum
Göteborgs Kulturnämnd
Heino Collection, Helsinki
HELABA, Landesbank Hessen-Thüringen, Frankfurt am Main
Helsingborg City
Helsingin kaupungin taidemuseo, Helsinki
HYPO Bank, München
Jenny ja Antti Wihurin Rahasto, Helsinki
Katriina Salmela-Hasan and David Hasan, Helsinki
KIASMA, Helsinki
Lars Swanljung Collection, Helsinki
Lobeck Collection, Wuppertal
Malmö Konsthall
Mario Testino Collection, Turin
Oulu Art Museum
Park Hotel Blub, Berlin
Paulon-säätiö, Helsinki
Pesch & Paulene, Hannover
Statens Konstråd, Malmö/Jönköping/Stockholm
Suomen Kulttuurirahasto, Helsinki
Tamperen Nykytaiteen Museo
Tekniska högskolan i Stockholm
Tom Cugliani Collection, New York
UPM-Kymmene Collection, Helsinki
Uppsala Läns Landsting
Västerås Konstmuseum
Winge advokatbyrå, Stockholm
Ystads Konstmuseum

Arbeiten im öffentlichen Raum
Works in public spaces

Aros Securities Inc., New York
Klinik für Neurochirurgie, Münster
Sammon Upper Secondary School, Tampere
The Ministry of Health and Social Affairs, Helsinki
University of Jönköping

VERZEICHNIS DER AUSGESTELLTEN WERKE LIST OF WORKS

Ohne Titel, 1992, Gabun, Holz, Industriefarben, 40 x 120 cm, Privatbesitz I Seite 16
gabon, wood, industrial paints, 40 x 120 cm, privately owned I page 16

Siebenmal Blau, 1992, Furnier, bemalt, Leinwand, 200 x 270 cm, Uppsala Läns Landsting I Seite 16
veneer, painted, canvas, 200 x 270 cm, Uppsala Läns Landsting I page 16

das gab es früher schon, 1993, Lackfarben auf Hartfaser, 100 x 80 cm, courtesy Contemporary Fine Arts, Berlin I Seite 17
enamel on fiberboard, 100 x 80 cm, courtesy Contemporary Fine Arts, Berlin I page 17

geradeaus, 1993, Lackfarben auf Hartfaser, 100 x 80 cm, courtesy Contemporary Fine Arts, Berlin I Seite 17
enamel on fiberboard, 100 x 80 cm, courtesy Contemporary Fine Arts, Berlin I page 17

Altneu, 1993, Lackfarben auf Leinwand, 91 x 71 cm, courtesy Contemporary Fine Arts, Berlin I Seite 18
enamel on canvas, 91 x 71 cm, courtesy Contemporary Fine Arts, Berlin I page 18

Bildobjekt I, 1993, Lackfarben auf Holz und Leinwand, 60 x 42,5 cm, Privatbesitz I Seite 18
enamel on wood and canvas, 60 x 42,5 cm, privately owned I page 18

Kreis & Kreis, 1993, Lackfarben auf Holz, Draht, 74 x 50 cm, Privatbesitz I Seite 19
enamel on wood, wire, 74 x 50 cm, privately owned I page 19

Ohne Titel, 1993, Lackfarben auf Zink, 100 x 60 cm, courtesy Contemporary Fine Arts, Berlin I Seite 19
enamel on zinc, 100 x 60 cm, courtesy Contemporary Fine Arts, Berlin I page 19

Transparent, 1993, Lackfarben auf Holz, 200 x 57 cm, Privatbesitz I Seite 19
enamel on wood, 200 x 57 cm, privately owned I page 19

Buntstiftbild auf Heft (kariert), 1993, Buntstift auf Papier, 29,7 x 42 cm, Temporäre Anordnung I Seite 20
crayons on exercise book, 29,7 x 42 cm, temporary arrangement I page 20

Bleistiftbild auf Block (kariert), 1993, Bleistift auf Papier, 29,7 x 42 cm, Temporäre Anordnung I Seite 20
pencils on notepad, 29,7 x 42 cm, temporary arrangement I page 20

Drawings on New York City, 1993, Blei- und Buntstift auf New York, Maße variabel (Manhattan-Größe), Temporäre Anordnung I Seite 21
pencils and crayons on New York, dimensions variable (Manhattan size), temporary arrangement I page 21

Probably the Best Red Painting in the World, 1994, Acryl auf Boden, Maße variabel, Ausstellungsansicht *Originalstora arbeten i DIN-format,* Forumgalleriet Malmö I Seite 7
acrylic on floor, dimensions variable, as exhibited *Originalstora arbeten i DIN-format,* Forumgalleriet Malmö I page 7

Wandfarbe, das einzig Wahre, 1994, Nessel und Wandfarbe auf Leinwand, 5-tlg., je 120 x 84 cm, courtesy Contemporary Fine Arts, Berlin I Seite 22/23
muslin and dispersion on canvas, 5 parts, each 120 x 84 cm, courtesy Contemporary Fine Arts, Berlin I page 22/23

So ist es immer, 1995, Lackfarbe auf Zink, 2-tlg., 84 x 120 cm, courtesy Contemporary Fine Arts, Berlin I Seite 24
enamel on zinc, 2 parts, 84 x 120 cm, courtesy Contemporary Fine Arts, Berlin I page 24

Porträts der Malerei, 1995, Lackfarbe auf Hartfaser, 12-tlg., je 70 x 50 cm, courtesy Contemporary Fine Arts, Berlin I Seite 25
enamel on fiberboard, 12 parts, each 70 x 50 cm, courtesy Contemporary Fine Arts, Berlin I page 25

Stereo, 1995, Acryl und Bleistift auf MdF, 3-tlg., 42 x 60 cm und 42 x 30 cm, courtesy Contemporary Fine Arts, Berlin I Seite 26
acrylic and pencil on MDF, 3 parts, 42 x 60 cm and 42 x 30 cm, courtesy Contemporary Fine Arts, Berlin I page 26

B. K., 1995, Lackfarbe auf Holz, 200 x 140 cm, KIASMA, Helsinki I Seite 35
enamel on wood, 200 x 140 cm, KIASMA, Helsinki I page 35

Meine großen Erfolge, 1996, Acryl und Buntstift auf Holz, 100 x 70 cm, Sammlung Bob Kelly, Göteborg I Seite 34
acrylic and crayon on wood, 100 x 70 cm, Bob Kelly Collection, Göteborg I page 34

Liebesbild, 1996, Faxpapier auf Wand, 420 x 300 cm, Installationsansicht, Taidehalli Helsinki I Seite 103
fax paper on wall, 420 x 300 cm, photo of installation, Taidehalli Helsinki I page 103

Hit Paraden, 1997, Mappe mit 10 Siebdrucken, je 54 x 40 cm, 35 Exemplare, Edition Larsen, Helsingborg I Seite 26/27
portfolio containing 10 screen prints, each 54 x 40 cm, edition of 35, Edition Larsen, Helsingborg I page 26/27

Bildextra!, 1997, Mischtechnik auf Papier, 51 x 36 cm, courtesy Contemporary Fine Arts, Berlin I Seite 85
mixed media on paper, 51 x 36 cm, courtesy Contemporary Fine Arts, Berlin I page 85

Se, 1997, Mischtechnik auf Papier, 42 x 30 cm, courtesy Contemporary Fine Arts, Berlin I Seite 85
mixed media on paper, 42 x 30 cm, courtesy Contemporary Fine Arts, Berlin I page 85

10 steg, 1997, Mischtechnik auf Papier, 42 x 30 cm, courtesy Contemporary Fine Arts, Berlin I Seite 85
mixed media on paper, 42 x 30 cm, courtesy Contemporary Fine Arts, Berlin I page 85

ansikts, 1997, Mischtechnik auf Papier, 42 x 29,5 cm, courtesy Contemporary Fine Arts, Berlin I Seite 85
mixed media on paper, 42 x 29,5 cm, courtesy Contemporary Fine Arts, Berlin I page 85

Fest & Jube, 1997, Mischtechnik auf Papier, 42 x 29,5 cm, courtesy Contemporary Fine Arts, Berlin I Seite 85
mixed media on paper, 42 x 29,5 cm, courtesy Contemporary Fine Arts, Berlin I page 85

Essence of freedom, 1999, Acryl, Blei- und Buntstift auf Holz, 61 x 81 cm, Sammlung Falckenberg, Hamburg I Seite 32
acrylic, pencil and crayon on wood, 61 x 81 cm, Falckenberg Collection, Hamburg I page 32

Man muss Gutes in Frage stellen, um Perfektes zu schaffen, 1999, Acryl, Blei- und Buntstift auf Holz, 100 x 140 cm, Sammlung Falckenberg, Hamburg I Seite 32
acrylic, pencil and crayon on wood, 100 x 140 cm, Falckenberg Collection, Hamburg I page 32

Nur die Wirklichkeit wirkt wirklicher, 1999, Acryl, Blei- und Buntstift auf Holz, 140 x 100 cm, Sammlung Falckenberg, Hamburg I Seite 33
acrylic, pencil and crayon on wood, 140 x 100 cm, Falckenberg Collection, Hamburg I page 33

Wir schlagen uns so durch, 2000, Acryl und Buntstift auf Holz, 140 x 100 cm, Sammlung Lobeck, Wuppertal I Seite 2
acrylic and crayon on wood, 140 x 100 cm, Lobeck Collection, Wuppertal I page 2

Ohne Titel, 2000, Acryl, Blei- und Buntstift auf Holz, 60 x 42 cm, Sammlung Falckenberg, Hamburg I Seite 32
acrylic, pencil and crayon on wood, 60 x 42 cm, Falckenberg Collection, Hamburg I page 32

Full head mask, 2000, Acryl, Blei- und Buntstift auf Holz, 81 x 61 cm, Sammlung Falckenberg, Hamburg I Seite 32
acrylic, pencil and crayon on wood, 81 x 61 cm, Falckenberg Collection, Hamburg I page 32

Die Stimmungsbombe, 2000, Acryl, Blei- und Buntstift auf Holz, 2-tlg., 100 x 280 cm, Sammlung Falckenberg, Hamburg I Seite 32/33
acrylic, pencil and crayon on wood, 2 parts, 100 x 280 cm, Falckenberg Collection, Hamburg I page 32/33

Der Kombi Pack, 2000, Acryl und Buntstift auf Holz, 70 x 100 cm, Privatbesitz I Seite 36
acrylic and crayon on wood, 70 x 100 cm, privately owned I page 36

Der Mann leidet wirklich, sagt einer, der ihn kennt, 2000, Acryl und Buntstift auf Holz, 100 x 70 cm, Claudia Tetzner, Düsseldorf I Seite 37
acrylic and crayon on wood, 100 x 70 cm, Claudia Tetzner, Düsseldorf I page 37

Accatone, 2000, Acryl und Buntstift auf Holz, 100 x 70 cm, Sammlung Lobeck, Wuppertal I Seite 38
acrylic and crayon on wood, 100 x 70 cm, Lobeck Collection, Wuppertal I page 38

Wo wird das enden?, 2000, Acryl und Buntstift auf Holz, 100 x 140 cm, courtesy Contemporary Fine Arts, Berlin I Seite 39
acrylic and crayon on wood, 100 x 140 cm, courtesy Contemporary Fine Arts, Berlin I page 39

Begeisterte Zurufe vom Straßenrand, 2000, Acryl und Bleistift auf Holz, 100 x 140 cm, Sammlung Lobeck, Wuppertal I Seite 40
acrylic and pencil on wood, 100 x 140 cm, Lobeck Collection, Wuppertal I page 40

Aber ich habe das immer schon gewußt von der, weil die nicht gerade schaut, immer so vorbei ..., 2000, Acryl und Bleistift auf Holz, 100 x 140 cm, Dr. Maurizio Deguili, Turin I Seite 41
acrylic and pencil on wood, 100 x 140 cm, Dr. Maurizio Deguili, Turin I page 41

No. 89, 2000, Acryl und Buntstift auf Holz, 140 x 100 cm, Sammlung Tom Cugliani, New York I Seite 42
acrylic and crayon on wood, 140 x 100 cm, Tom Cugliani Collection, New York I page 42

No. 95, 2000, Acryl und Buntstift auf Holz, 170 x 120 cm, Sammlung Gabriel Sulkowski, Düsseldorf I Seite 42
acrylic and crayon on wood, 170 x 120 cm, Gabriel Sulkowski Collection, Düsseldorf I page 42

No. 87, 2000, Acryl und Buntstift auf Holz, 140 x 100 cm, Prof. Dr. Arndt-René Fischedick, Münster I Seite 42
acrylic and crayon on wood, 140 x 100 cm, Prof. Dr. Arndt-René Fischedick, Münster I page 42

No. 85, 2000, Acryl und Buntstift auf Holz, 100 x 140 cm, Sammlung Lobeck, Wuppertal I Seite 43
acrylic and crayon on wood, 100 x 140 cm, Lobeck Collection, Wuppertal I page 43

No. 96a, 2000, Acryl und Buntstift auf Holz, 100 x 140 cm, Privatbesitz I Seite 43
acrylic and crayon on wood, 100 x 140 cm, privately owned I page 43

No. 88, 2000, Acryl und Buntstift auf Holz, 140 x 100 cm, courtesy Contemporary Fine Arts, Berlin I Seite 43
acrylic and crayon on wood, 140 x 100 cm, courtesy Contemporary Fine Arts, Berlin I page 43

No. 98, 2000, Acryl und Buntstift auf Holz, 100 x 140 cm, Sammlung Tom Cugliani, New York I Seite 45
acrylic and crayon on wood, 100 x 140 cm, Tom Cugliani Collection, New York I page 45

No. 93, 2000, Acryl und Buntstift auf Holz, 170 x 120 cm, Malmö Konsthall I Seite 45
acrylic and crayon on wood, 170 x 120 cm, Malmö Konsthall I page 45

No. 103/E, 2000, Acryl und Buntstift auf Holz, 60 x 40 cm, Hans Berger, Kiel I Seite 46
acrylic and crayon on wood, 60 x 40 cm, Hans Berger, Kiel I page 46

No. 103/F, 2000, Acryl und Buntstift auf Holz, 60 x 40 cm, Hans Berger, Kiel I Seite 47
acrylic and crayon on wood, 60 x 40 cm, Hans Berger, Kiel I page 47

Weil mein Job es erfordert, 2001, Acryl und Bleistift auf Holz, 100 x 70 cm, Forsa-Meinungsforschungsinstitut, Berlin I Seite 44
acrylic and pencil on wood, 100 x 70 cm, Forsa-Meinungsforschungsinstitut, Berlin I page 44

Zum Tanzen und Mitjubeln, 2001, Acryl und Bleistift auf Holz, 100 x 70 cm, Forsa-Meinungsforschungsinstitut, Berlin I Seite 44
acrylic and pencil on wood, 100 x 70 cm, Forsa-Meinungsforschungsinstitut, Berlin I page 44

Schluss mit langweilig, 2001, Acryl und Bleistift auf Holz, 100 x 70 cm, Forsa-Meinungsforschungsinstitut, Berlin I Seite 44
acrylic and pencil on wood, 100 x 70 cm, Forsa-Meinungsforschungsinstitut, Berlin I page 44

The only thing you could say is ..., 2001, Acryl und Bleistift auf Holz, 140 x 100 cm, Sammlung Lobeck, Wuppertal I Seite 48
acrylic and pencil on wood, 140 x 100 cm, Lobeck Collection, Wuppertal I page 48

Er trank gerne mal einen Schluck, 2001, Acryl und Buntstift auf Holz, 70 x 100 cm, Pesch & Paulene, Hannover I Seite 49
acrylic and crayon on wood, 70 x 100 cm, Pesch & Paulene, Hanover I page 49

Z. has a bad hair day, 2001, Acryl und Bleistift auf Holz, 140 x 100 cm, Sammlung Heino, Helsinki I Seite 50
acrylic and pencil on wood, 140 x 100 cm, Heino Collection, Helsinki I page 50

DIE AUTOREN

Beate Ermacora
Geb. 1956, Kunsthistorikerin; 1987 Promotion; 1986–1988 Kuratorin an der Tiroler Landesgalerie im Taxispalais, Innsbruck; 1988–1992 freiberufliche Kunstautorin und Kuratorin in Düsseldorf; 1992/93 wissenschaftliche Mitarbeiterin am Kunstverein Frankfurt am Main; 1993–2000 Kustodin der Gemälde- und Skulpturensammlung der Kunsthalle zu Kiel; 1996–1998 Lehraufträge an der Christian-Albrechts-Universität zu Kiel und an der Muthesius Kunsthochschule, Kiel; 2000–2002 kommissarische Direktorin der Kunsthalle zu Kiel und geschäftsführende Vorsitzende des Schleswig-Holsteinischen Kunstvereins, Kiel; 2002–2005 stellvertretende Direktorin der Krefelder Kunstmuseen; seit 2005 Direktorin des Kunstmuseums Mülheim an der Ruhr in der Alten Post.

Harald Falckenberg
Geb. 1943, Jurist und Sammler zeitgenössischer Kunst; 1967–1979 Repetitor bei den juristischen Lehrgängen Alpmann und Schmidt in Berlin und Hamburg; 1972 Promotion; seit 1979 Geschäftsführer in einem Hamburger Familienunternehmen; 1992 Berufung zum ehrenamtlichen Richter am Hamburger Verfassungsgericht; seit 1999 Vorsitzender des Kunstvereins in Hamburg; seit 2001 Leiter der Phoenix Kulturstiftung/Sammlung Falckenberg in Hamburg-Harburg mit zahlreichen Sammlungspräsentationen und Wechselausstellungen.

Oliver Zybok
Geb. 1972, Kunsthistoriker; 1997–1999 freie kuratorische Tätigkeit am M. K. Ciurlionis Art Museum, Kaunas (Litauen); 1999–2001 Kustos am Städtischen Museum Leverkusen Schloss Morsbroich; 2001/02 Kurator am Museum für Angewandte Kunst Köln; 2002/03 Lehrauftrag an der Johann Wolfgang von Goethe-Universität, Frankfurt am Main; seit 2002 Kurator am Künstlerverein Malkasten, Düsseldorf; 2003 Promotion, Lehrauftrag an der Hochschule der Bildenden Künste Dresden; seit 2003 Lehrbeauftragter an der University of Helsinki, Academy for Fine Arts.

THE AUTHORS

Beate Ermacora
Born in 1956; art historian; doctorate 1987; 1986–1988 curator at the Tiroler Landesgalerie im Taxispalais, Innsbruck; 1988–1992 freelance author and curator in Düsseldorf; 1992/93 research assistant at the Kunstverein Frankfurt am Main; 1993–2000 curator of the painting and sculpture collection at the Kunsthalle zu Kiel; 1996–1998 lecturer at the Christian Albrecht University and Muthesius Kunsthochschule, both in Kiel; 2000–2002 interim Director of the Kunsthalle zu Kiel and Executive Director of the Schleswig-Holsteinischer Kunstverein, Kiel; 2002–2005 Assistant Director of the Krefeld Kunstmuseen; since 2005 Director of the Kunstmuseum Mülheim an der Ruhr in der Alten Post.

Harald Falckenberg
Born in 1943, lawyer and collector of contemporary art; from 1967–1979 coached law students at Alpmann und Schmidt in Berlin and Hamburg; doctorate in 1972; since 1979 CEO of family-owned company in Hamburg; 1992 appointed honorary judge at Hamburg Constitutional Court; since 1999 Chairman of the Kunstverein in Hamburg; since 2001 Director of the Phoenix Kulturstiftung/Sammlung Falckenberg in Hamburg-Harburg with numerous presentations of the collection and other exhibitions.

Oliver Zybok
Born in 1972, art historian; 1997–1999 freelance curator at the M. K. Ciurlionis Art Museum in Kaunas, Lithuania; 1999–2001 curator at the Städtisches Museum Leverkusen Schloss Morsbroich; 2001/02 curator at the Museum for Applied Art, Cologne; 2002/03 lecturer at the Johann Wolfgang von Goethe University, Frankfurt am Main; since 2002 curator at the Künstlerverein Malkasten, Düsseldorf; doctorate in 2003; lecturer at the Hochschule der Bildenden Künste Dresden; since 2003 lecturer at the University of Helsinki, Academy of Fine Arts.

Liebesbild, 1996, Installationsansicht I Photo of installation, Taidehalli Helsinki